REFLECTIONS IN LIGHT

GORDON N. CONVERSE

The work of a photojournalist

Compiled and Edited by Stephen T. Graham

Designed by Elizabeth Greely

Books from
THE CHRISTIAN SCIENCE MONITOR.
Boston, Massachusetts

© 1989 by The Christian Science Publishing Society

Acknowledgement: We are grateful to Gordon N. Converse for his input in developing this book and for providing many of the photos from his personal archives.

Book design by Yellow Inc., Needham, Massachusetts.

Typeset in Bauer Bodoni by dnh typesetting, inc., Cambridge, Massachusetts.

Signatures and jackets printed by The Nimrod Press, Printers and Engravers, Boston, Massachusetts.

Bound by Horowitz/Rae Book Manufacturers, Inc., Fairfield, New Jersey.

Printed in the United States of America.

ISBN 0-87510-205-0

Chirayath
November, 1993

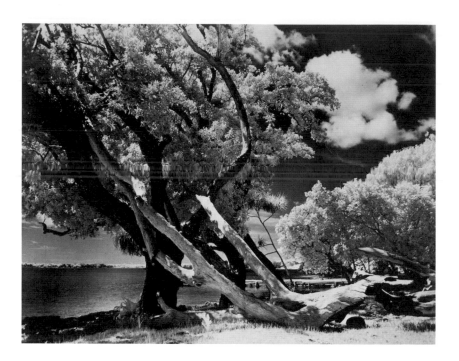

■ This photograph appeared in *The Christian Science Monitor* in 1943. Gordon Converse took it in New Hebrides in the southwest Pacific when he was in the United States Navy, using infrared film. It was his first photograph ever published in *the Monitor*, appearing three years before he was hired.

■ This book is not a picture book. It is not a "how to" book on taking good photographs. Nor is it a travelogue of Gordon Converse's trips (although it does contain his work from all over the world).

"Reflections in Light" is a celebration of the work of one individual whose goal was always to do his very best.

Gordon Converse came to his one job and lifetime career the day he left the United States Navy. He spent the next 40 years enlarging his concept of that job, pioneering the field of photojournalism and giving it new dimension. He approached his assignments for *The Christian Science Monitor* with a strong dedication to taking the best and most honest photographs possible.

When discussing his work, Mr. Converse inevitably returns to the vital importance of light. Of all the elements necessary in photography, light is the most basic, for light is all that interacts with film to create a photographic image. This collection of images is not significant, however, simply because Mr. Converse mastered the use of available light. The photography found in this book—work every bit as personal as an author's own style of writing—is unique because its creator clearly understood that the light he was working with was an enlightened understanding of man and nature.

Just as the available light was necessary to produce what he calls "the perfect picture," so too was inspiration and understanding (both dictionary definitions for "light") necessary for him to do his work.

As one explores his photographs and considers his comments, it is clear that through his work Mr. Converse is communicating a personal understanding of life, showing a commitment to finding and chronicling that which is true and good and honest. He once wrote concerning his work: "As I travel from the Andes to the Himalayas or down into Africa's Rift Valley, I am constantly in search of positive statements about man—that he can find hope, freedom, happiness, and dignity wherever he might be."

We trust the following pages will give insight into Gordon Converse's profound and personal view of life. We hope to communicate some of the inspiration that brought him honors for "promoting the cause of goodwill and understanding among all the people of our nation" and for "helping to advance the skills and arts of communication with an unusually high degree of dedication and ability." Above all, we hope readers will find enjoyment and benefit in what this book contains.

Stephen T. Graham

The day I started at The Christian Science Monitor I saw a sign that said something I've never forgotten: "a craftsman is someone who does whatever he is given to do better than others feel is necessary." That's what I tried to do. When I got an assignment, I just kept at it until I could say I had the best photograph I could possibly make.

Gordon N. Converse

On stage were more than a hundred members of the Boston Symphony Orchestra, one conductor, and one green photographer. The imposing Serge Koussevitzky had grudgingly given permission to have photographs taken of him at a busy morning rehearsal. With a large Speed Graphic camera and a pocketful of flash bulbs I found a comfortable spot on the floor somewhere in the maze of first and second violins. My view of the podium was excellent until I was forced to start dodging the violin bows that were swishing through the air like spears.

The orchestra had warmed up and the time seemed right to start taking pictures of conductor Koussevitzky in action. We were deep into Beethoven's Fifth Symphony. I raised my camera and squeezed the flash button. Then— POW! The large flash bulb exploded with the sound of a gun firing, and the defective bulb showered the entire stage with burning bits of magnesium. The music abruptly stopped. Dead silence filled the grand hall. Koussevitzky stiffened and slowly turned. His eyes focused directly on me. He shouted just one word in Russian—OUT! (I needed no translation.)

This incident proved to be useful. It forced me to experiment with natural light photography long before it seemed wise or practical for newspaper work. I vowed never again to allow my camera to invade or disrupt the lives of other people. Since that day I have never used a flash on any of my cameras. Simply, it's not polite!

I never know where my eyes will lead me next. I love to discover and observe the play of light around the clock.

Needham, Massachusetts, USA

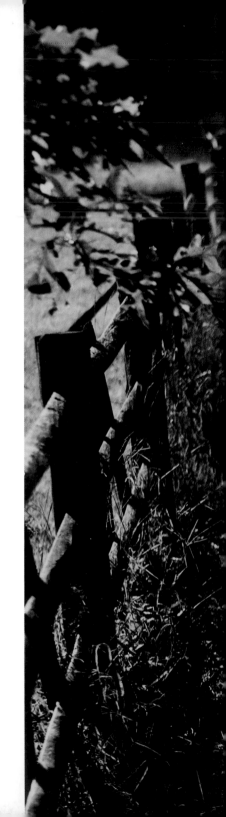

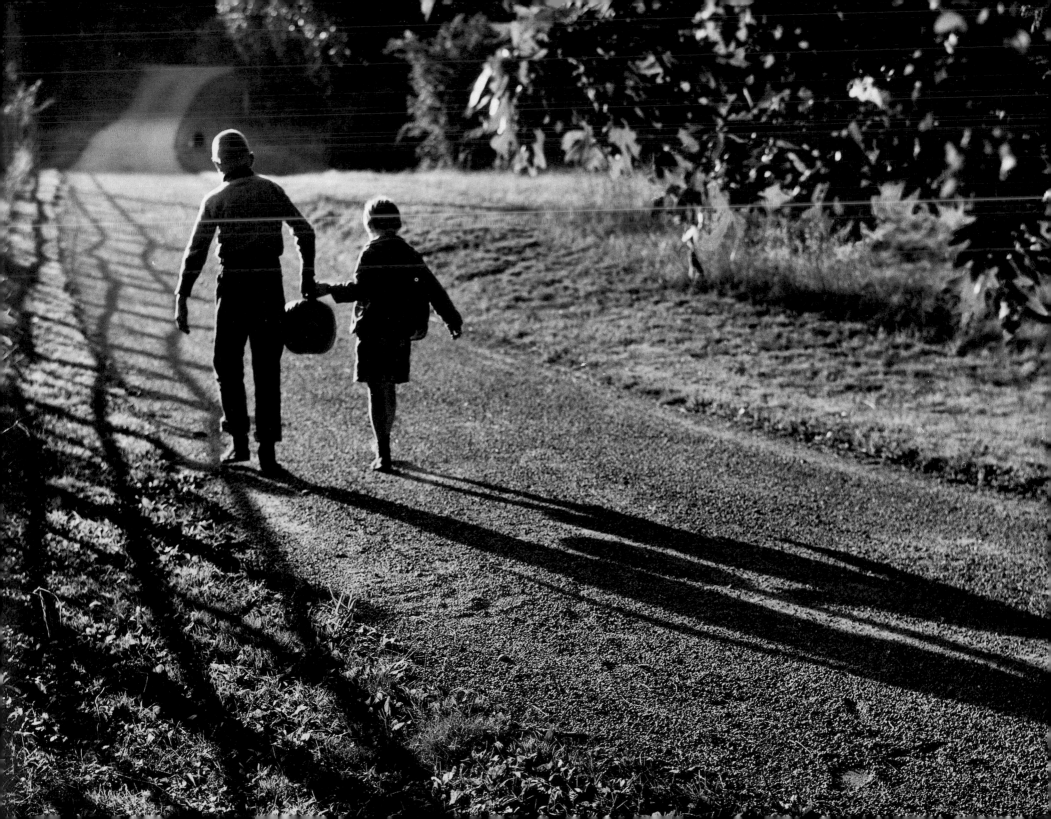

It's so necessary to have a feeling for light and a sense of timing when working with a camera.

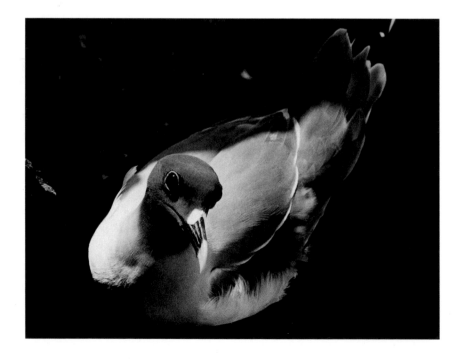

Galapagos Islands, Ecuador Dubrovnik, Yugoslavia

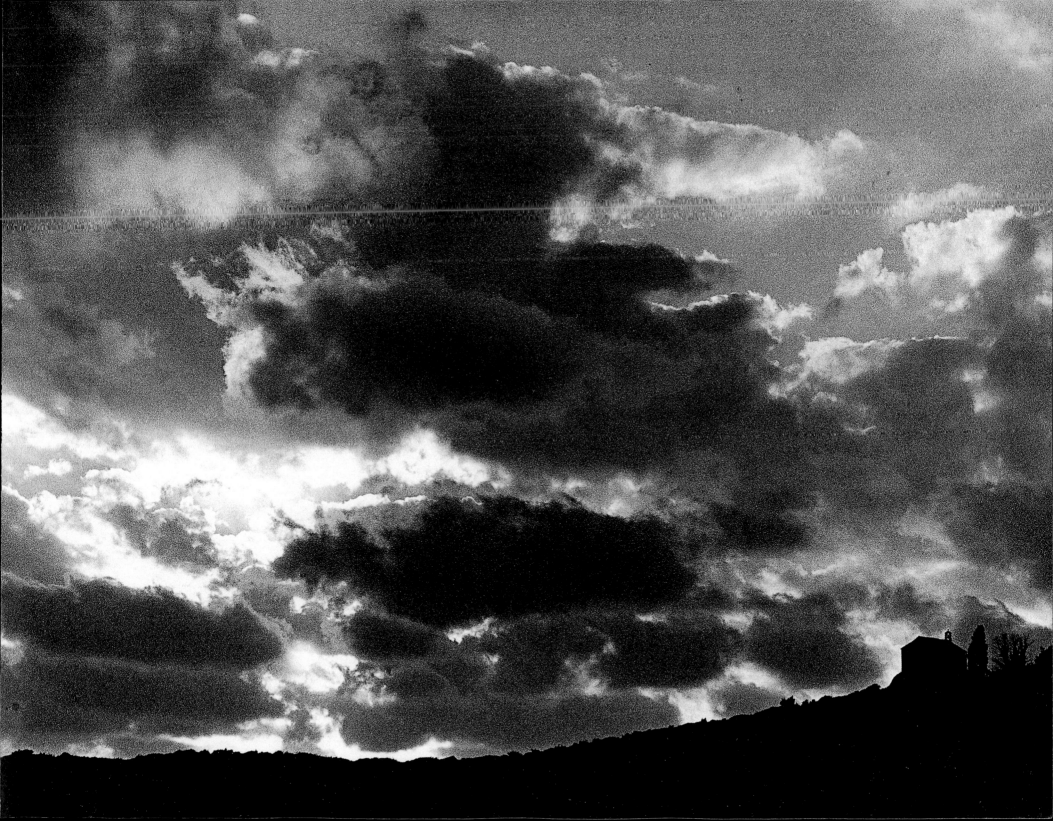

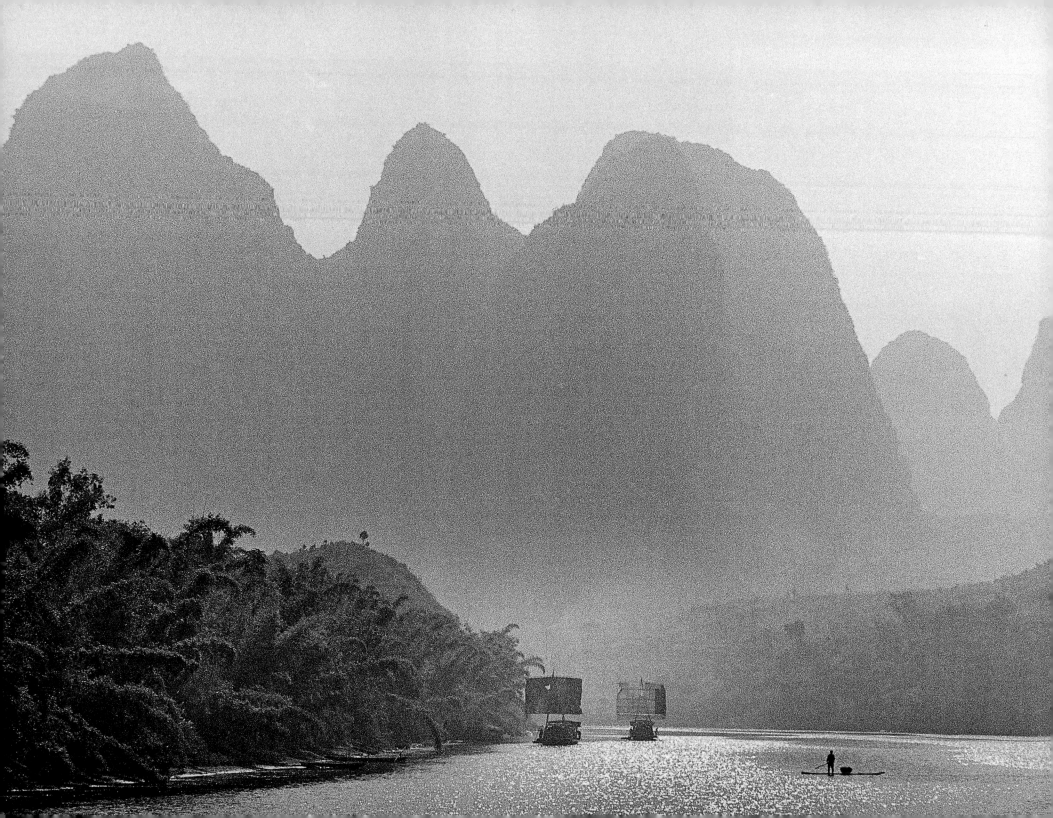

Li River, China

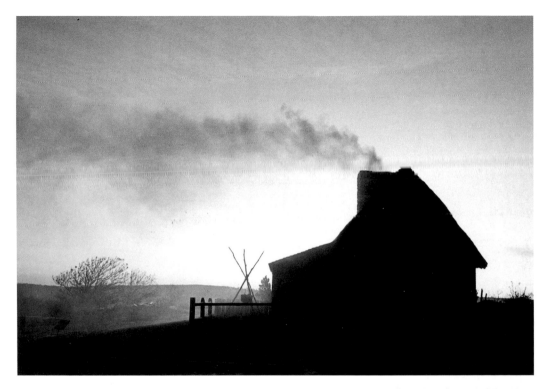

Plymouth, Massachusetts, USA

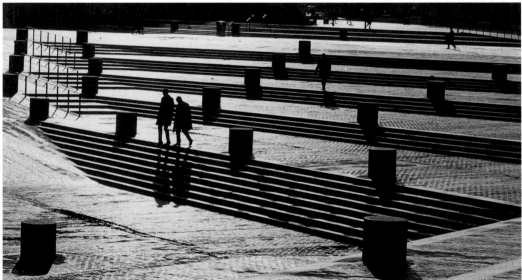

Boston, Massachusetts, USA

Soft, natural light is my favorite for photographing people. It is the kind of light you find on a bright cloudy day when the sun doesn't quite break through.

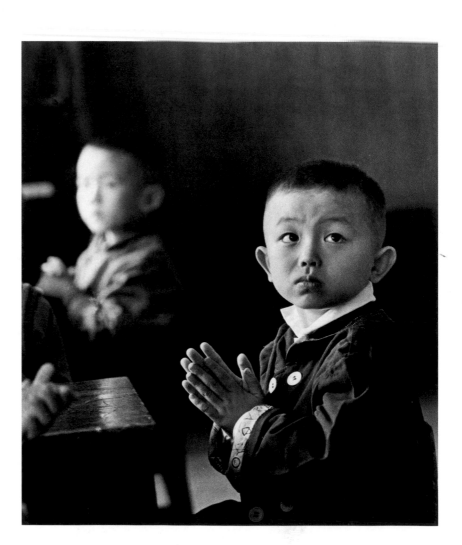

China

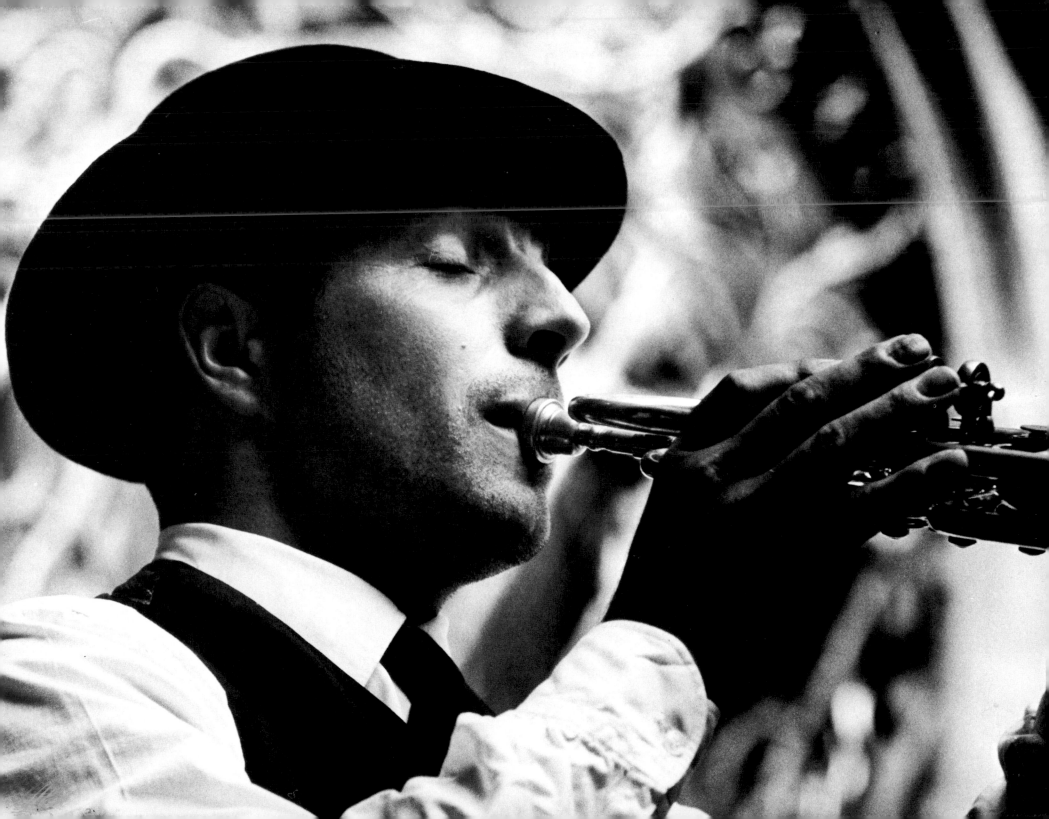

Communicating with one's face—just smiling and letting people know that you are friendly —is part of the "universal language" that allows one to photograph people without invading their privacy.

China

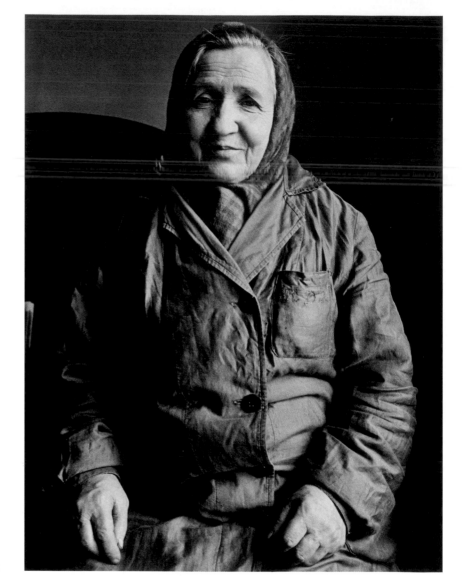

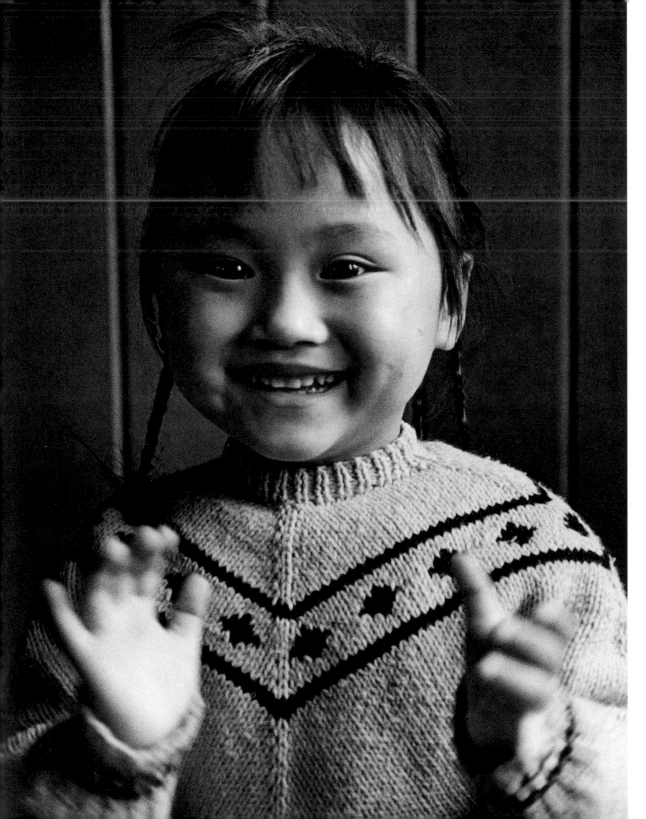

China

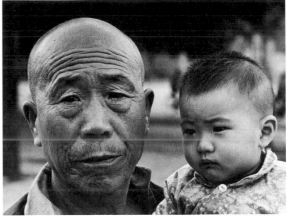

■ This man would not let me take his picture, so I asked if I could take one of his grandchild. And when I photographed the baby, I also began to get him as well. Soon, out of the corner of my eye, I could see his own expression begin to soften.

Beijing, China

A good photographer learns to use light to its fullest.

■ I had flown with our Washington correspondent to New Delhi, India, where the *Monitor* had been granted an interview with Prime Minister Jawaharlal Nehru. We had an appointment on a Sunday morning.

When we arrived at ten o'clock, I was told immediately that I could not attend the interview because I was a photographer; when the interview was over, I would be permitted to take a picture. Well, I had no intention of coming all the way to India for just one picture! I asked if I might at least sit in on the interview.

As the interview started, I listened quietly. After about ten minutes, I carefully reached into my attaché case, which held my basic equipment, and clicked the shutter two or three times so that Nehru could get used to its sound.

Suddenly I realized that there was only one bit of light coming into the room from a small window in the back. Nehru was almost in total blackness and there didn't seem to be enough light to work with.

But I noticed that as the sun moved, the light from over his shoulder would soon hit the blotter on his desk and perhaps reflect onto his face. This would, I suspected, yield enough soft light for a few acceptable pictures. Then I realized that to his left was a pure white telephone, and that as the sun moved it would soon reflect off of this telephone to provide a side highlight. I would have light from three directions: the back light from over his shoulder, the soft front light from the blotter, and the side highlight from the telephone, all coming from the same source and giving real depth to the scene.

In the same way that a three-legged stool rests equally on all its legs, the photograph was supported by light that shined on Nehru from three different angles.

I lifted my camera to my eye and took a few pictures. Nehru glanced over and then continued on with his interview. He paid no more attention, and within an hour I exposed two rolls of film—72 pictures of Nehru altogether.

After he had ended the interview, he asked me if I would like him to stand for a picture. I said that I already had all I needed, and thanked him.

New Delhi, India

I always tried to take the best possible picture in
the kindest possible way.

Bon Xon, Laos

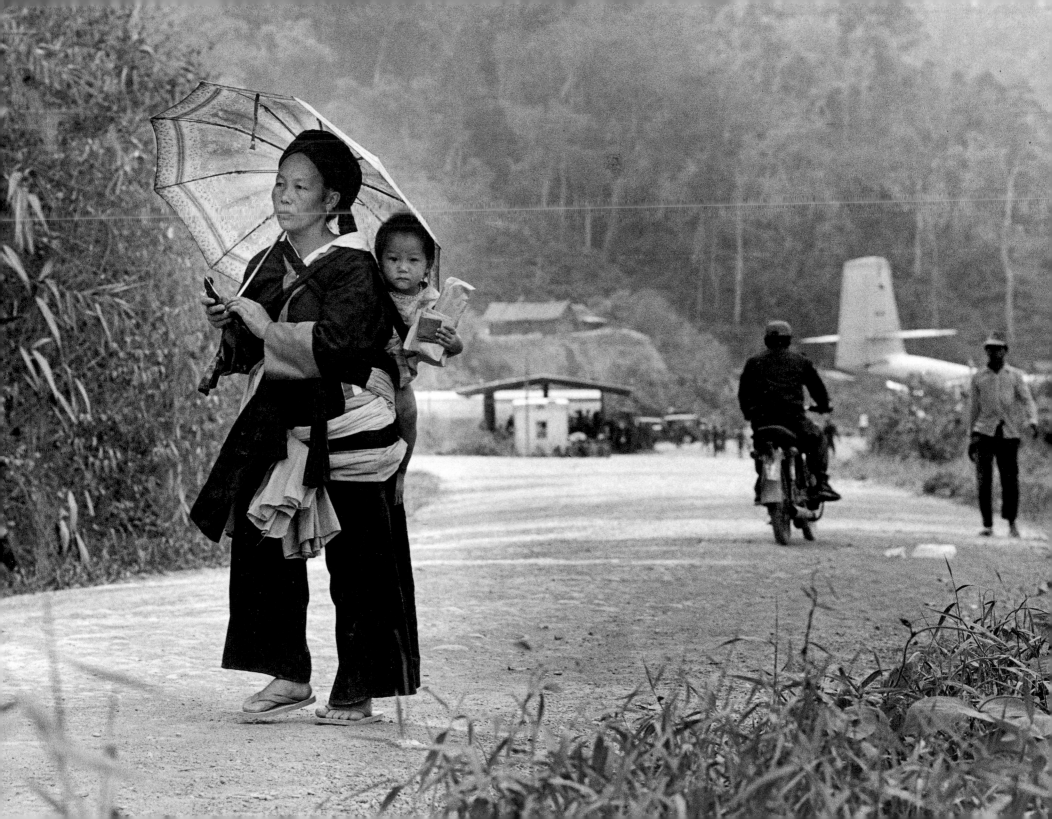

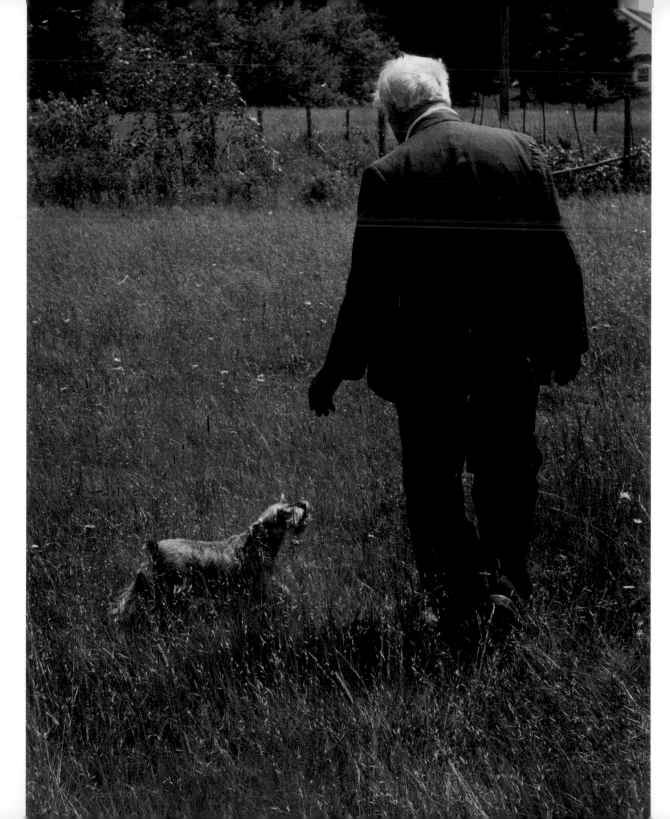

Vermont

Boston, Massachusetts, USA

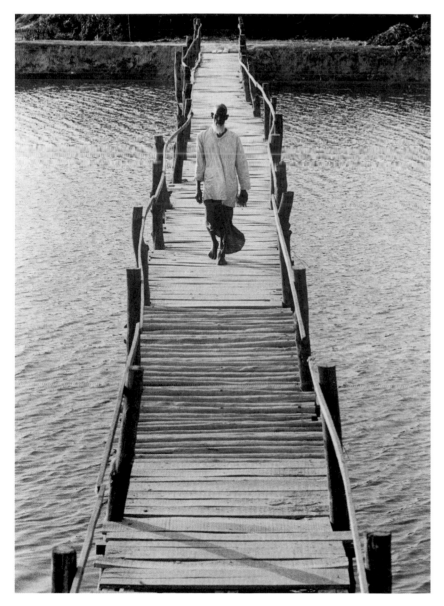

Bangladesh

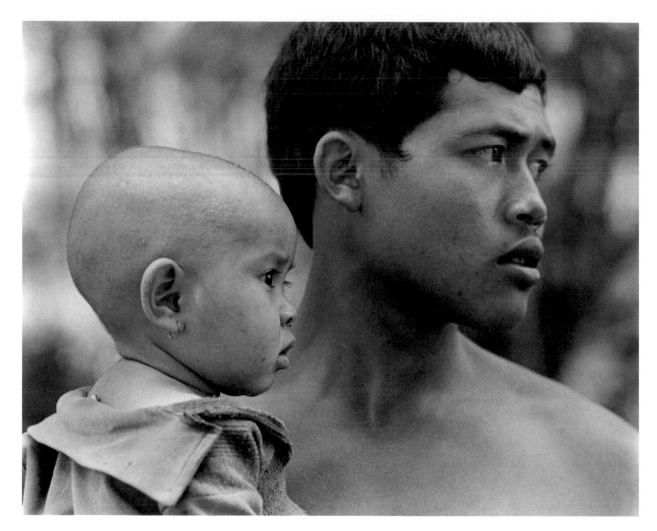

Bali, Indonesia

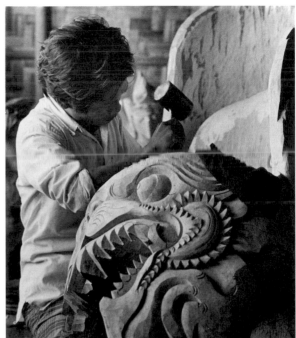

Bali, Indonesia

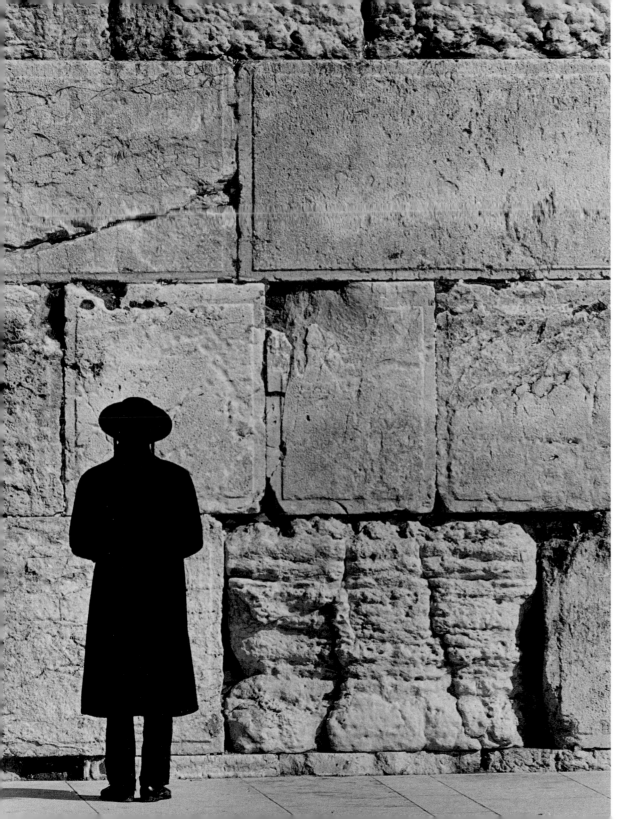

Jerusalem, Israel

A good photograph is really made up of light and forms. Some photographers only work with the range of tones from black to white.

■ One of the dictionary definitions for light is "inspiration." A photographer must learn to see, not just the surface of physical objects, but their depth as well. Photography is primarily a process of visualization. It must be a very personal reflection of your feelings. Otherwise you're just taking snapshots.

Doesn't light also mean understanding? If so, then the more that we understand about a given subject, the more we are going to put into our photographs. Much of what we photograph is really a reflection of what we are thinking. That is why ten photographers on the same assignment can often come up with as many different photographs—some good and some bad.

Vietnam

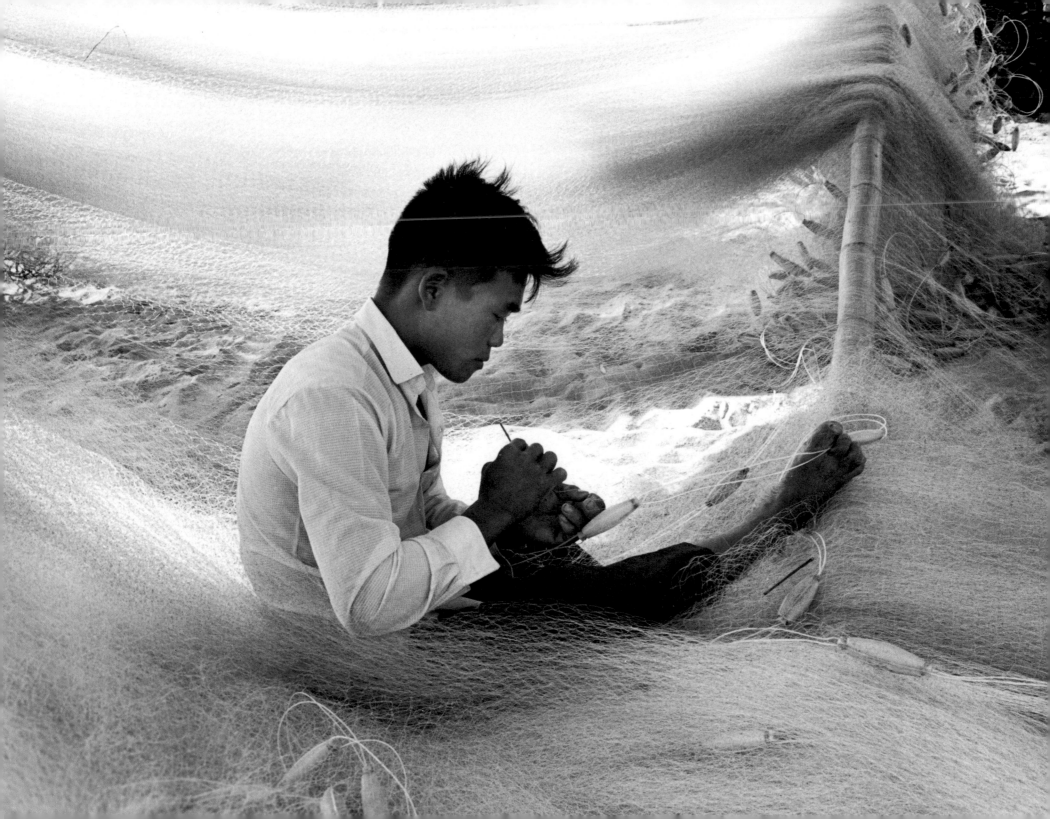

It is well to remember that it is light, emitted or reflected by the subject, that passes through the lens and onto the film. Learn what it can do: play with it, paint with it, mold it. Become a master of light.

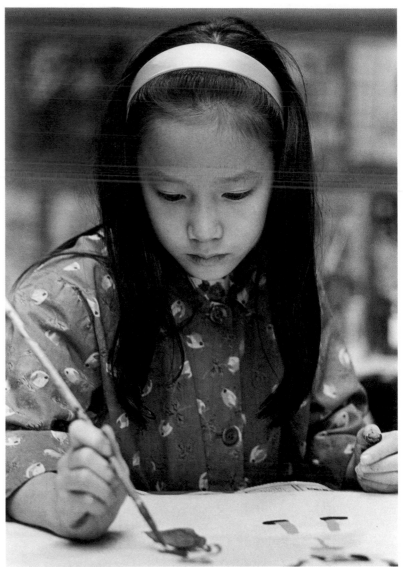

New York, New York, USA

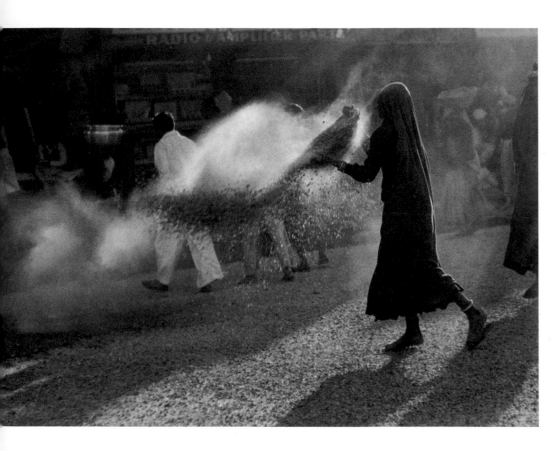

Delhi, India

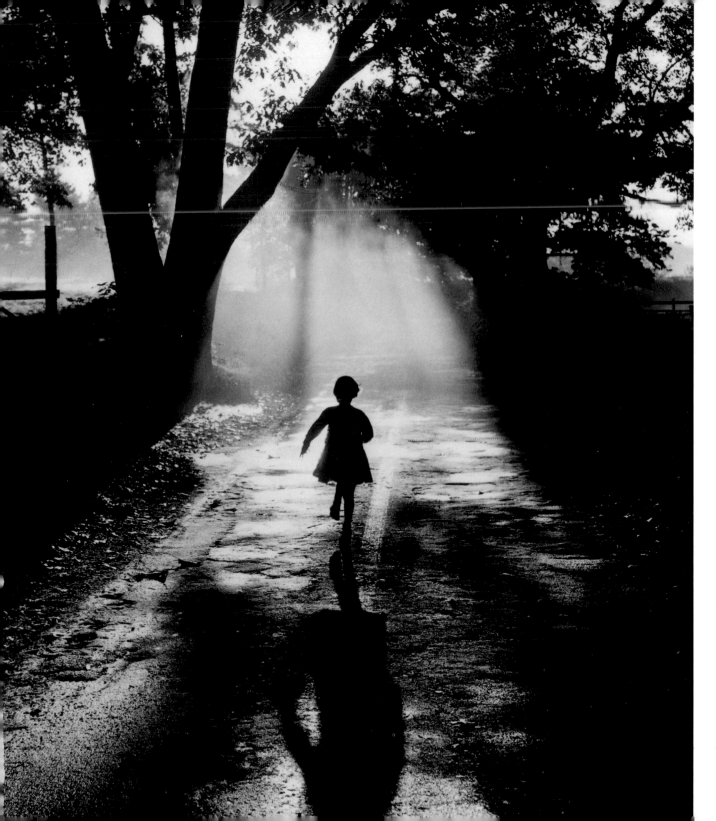

■ Every once in a while a photographer takes a photograph that truly pleases him or her. Usually it is one that needs little or no caption at all. It is one that seems to be timeless and enjoyed over and over again. I consider this to be one of those photographs.

Early one fall morning our family piled into the car for a trip north to Vermont to see the colorful fall foliage. As we pulled out of our driveway in a suburb of Boston, I noticed a small patch of fog at the end of our road. It was disappearing fast from the warm rays of the rising sun. The scene had the ingredients of a good picture—strong light, rich texture—but it needed movement.

In a split second I told our younger daughter to hop out of the car and run down the street as fast as she could. She was used to unusual requests from her dad the photographer and obeyed spontaneously.

This was one of those occasions when I knew, as the shutter clicked, that everything was just right. I did not have to see the developed film to find out if I had recorded correctly what I had seen.

Before my daughter could retrace her steps, the fog had dissolved.

Hundreds of times since, I have passed the same place and have never quite seen the mood or play of light as I did that day. Although I've travelled around the world many times, this photograph, taken in front of my own home, has proved to be my most popular. Needham, Massachusetts, USA

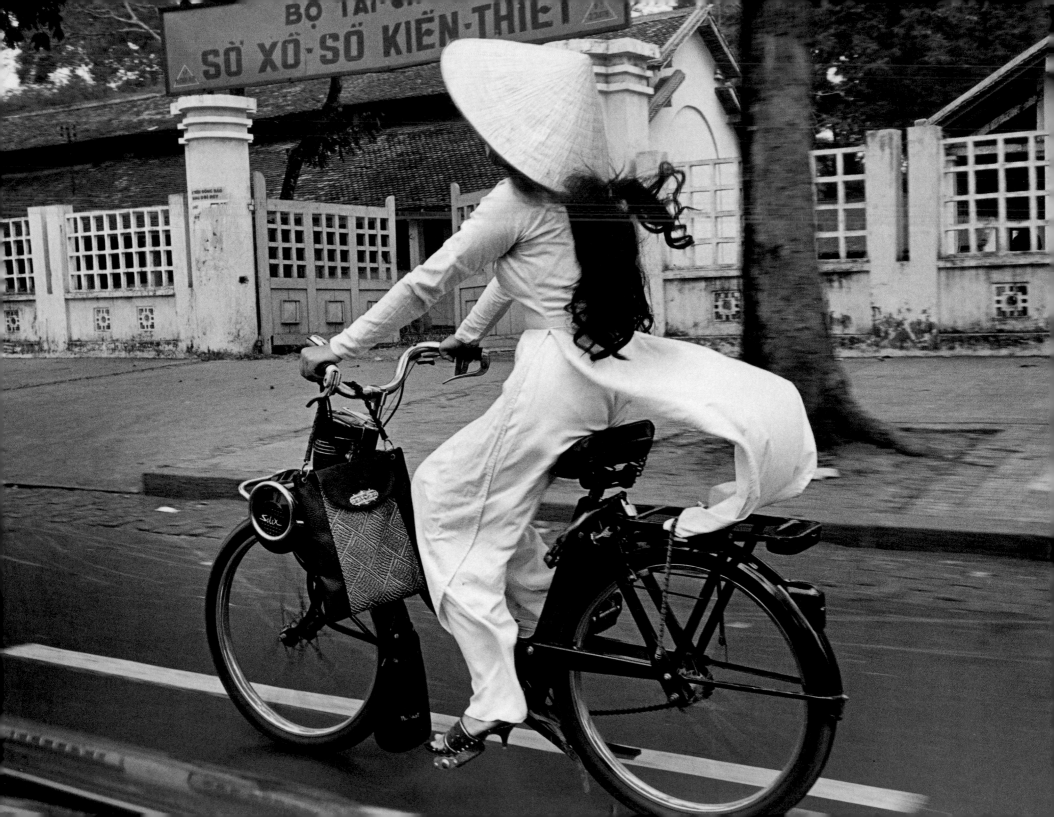

Of all the means of expression, photography is the only one that instantly fixes forever the fleeting moments of time.

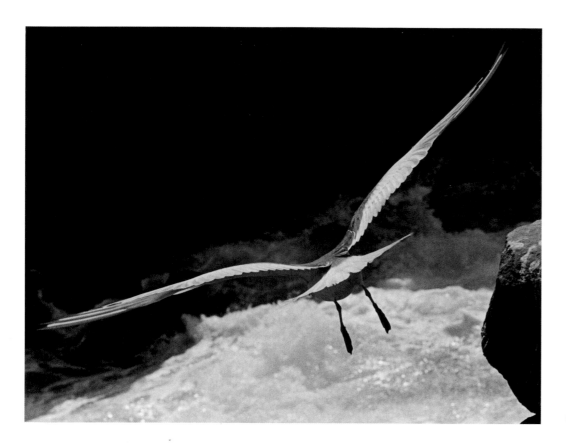

Galapagos Islands, Ecuador

Photographers deal with things and elements that are constantly vanishing. They must work fast before they dissolve into the past.

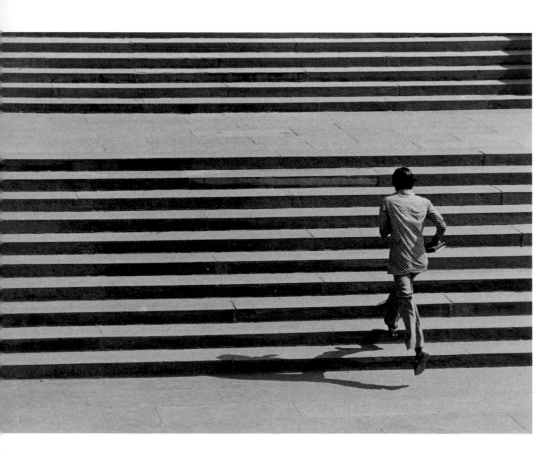

New Delhi, India

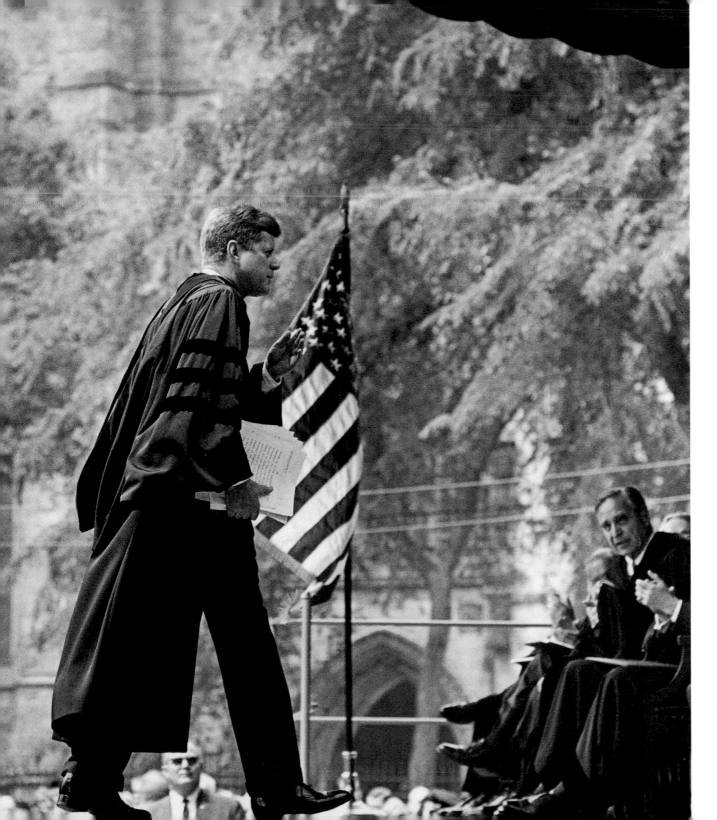

Hyannis Port,
Massachusetts

November 12, 1968

Dear Mr. Converse,

 Thank you very much for the
photograph of my late son, the
President, which you sent to me.
It will always be one of my favorites.

 I cannot gaze on it too long.
The sense of urgency which he per-
sonified and which you captured in
such a superlative way overwhelms
me.

 Sincerely,

 Rose Kennedy
 Mrs. Joseph P. Kennedy

Mr. Gordon N. Converse
Chief Photographer
THE CHRISTIAN SCIENCE MONITOR
One Norway Street
Boston, Massachusetts

I hope to meet you sometime in Boston.
RK

New Haven, Connecticut, USA

■Machu Picchu, the lost city of the Incas, is surely one of the most isolated spots on earth. Perched on a mountaintop high in the Andes of Peru, this mysterious city remained hidden from the world for almost 300 years, covered by centuries of jungle growth. It was discovered by explorer Hiram Bingham in 1911.

I spent a night on the peaks above this ancient stone city. Long before dawn I was up with my camera, ready to capture the morning light coming over the Andes. Because of the darkness I was unaware that the site had become socked in with heavy fog during the night.

Good photography seemed utterly hopeless. I had come so far—by train, plane and bus, through swollen streams and even flash floods. I was determined to get something on film . . . anything. I climbed to the highest peak, sat in the early morning chill, and waited for something to happen.

Suddenly something started to change. There was movement in the air. Light began to break through. Mist melted away. Big, white fluffy clouds began to roll in, filling the skies above and the mountain passes below. Everything became excitingly alive. The mountain ranges all around Machu Picchu were revealed in incredible splendor. I couldn't wait to catch what I was feeling inside with my camera. It was the kind of moment when you know that something very special is happening to you.

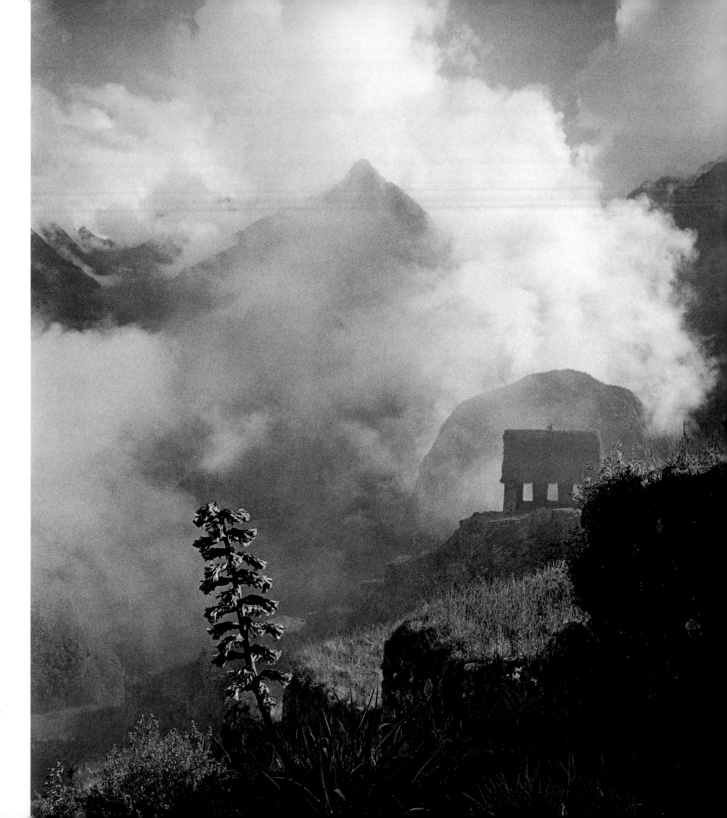

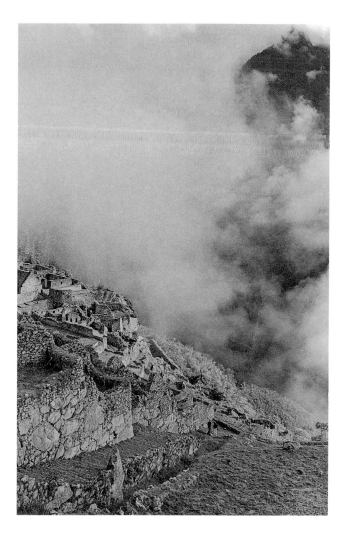 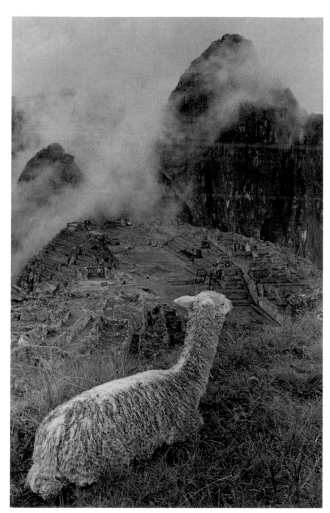

Machu Picchu, Peru

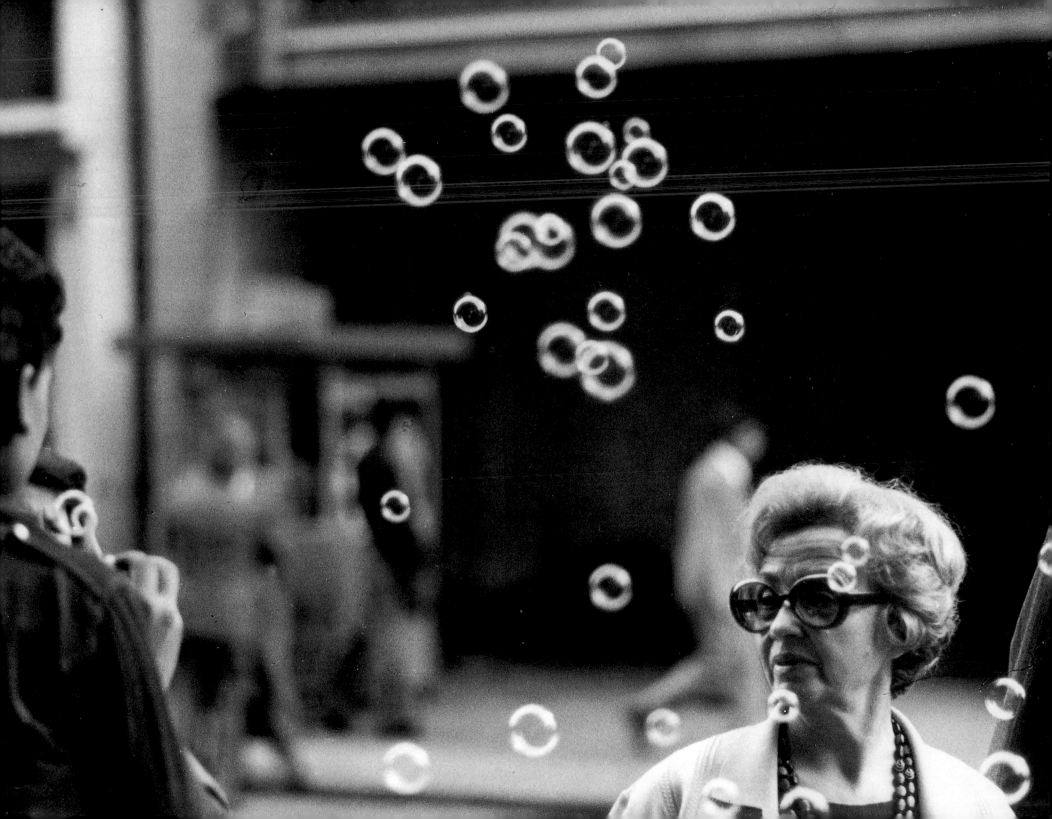

Belgrade, Yugoslavia

Ideas often come too fast to do anything with at the moment. I found it helpful to carry a little notebook in my pocket to jot these ideas down for a future time. Everything new comes to us first as an idea. We must learn to capture them as they come.

Hiroshima, Japan

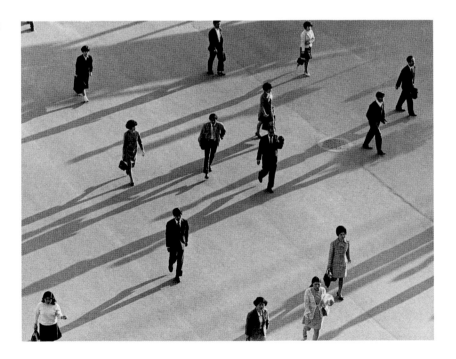

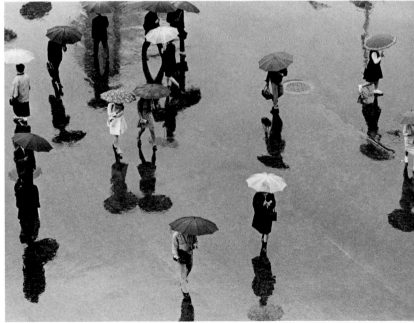

Sometimes I would spend hours on a single photo-graph, stalling, delaying, waiting for something to happen.

■ I had flown high into Nepal's Himalayas and spent a day photographing scenes familiar to few people on earth.

The day was photographically productive and by late afternoon the grandeur of the Himalayas had left me both breathless and tired. I was ready to leave. It seemed to me that I had photographed everything—people, village scenes, markets, mountains, wild monkeys, and exotic birds. I had reached the point where I felt I couldn't see or photograph another thing.

But my eyes continued to roam and take in everything as I headed down the dusty road toward the waiting plane. Suddenly I noticed a giant tree a good distance away. It seemed to be the widest tree I had ever seen—only the Himalayas could have produced such a tree. As if to make it more visually attractive, a small thatched-roofed shelter rested beneath the spreading limbs. Good but not complete, I thought. I knew it needed a third element, but I didn't know what it was.

So I waited and waited. Then came the sound of voices. A small group of Nepalese women came down the road and moved toward the village below.

Suddenly I was able to capture the moment when all elements in the scene worked together harmoniously and instantly. And as is so often the case, the last picture I took became my favorite for the day.

Pokhara, Nepal

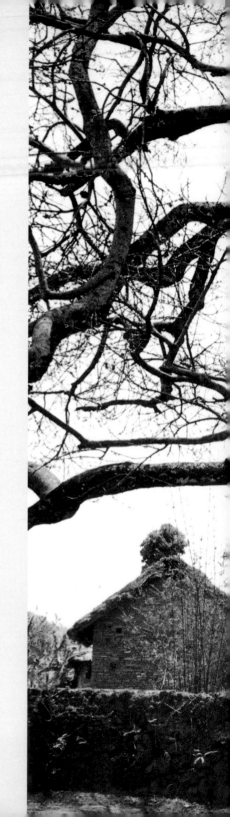

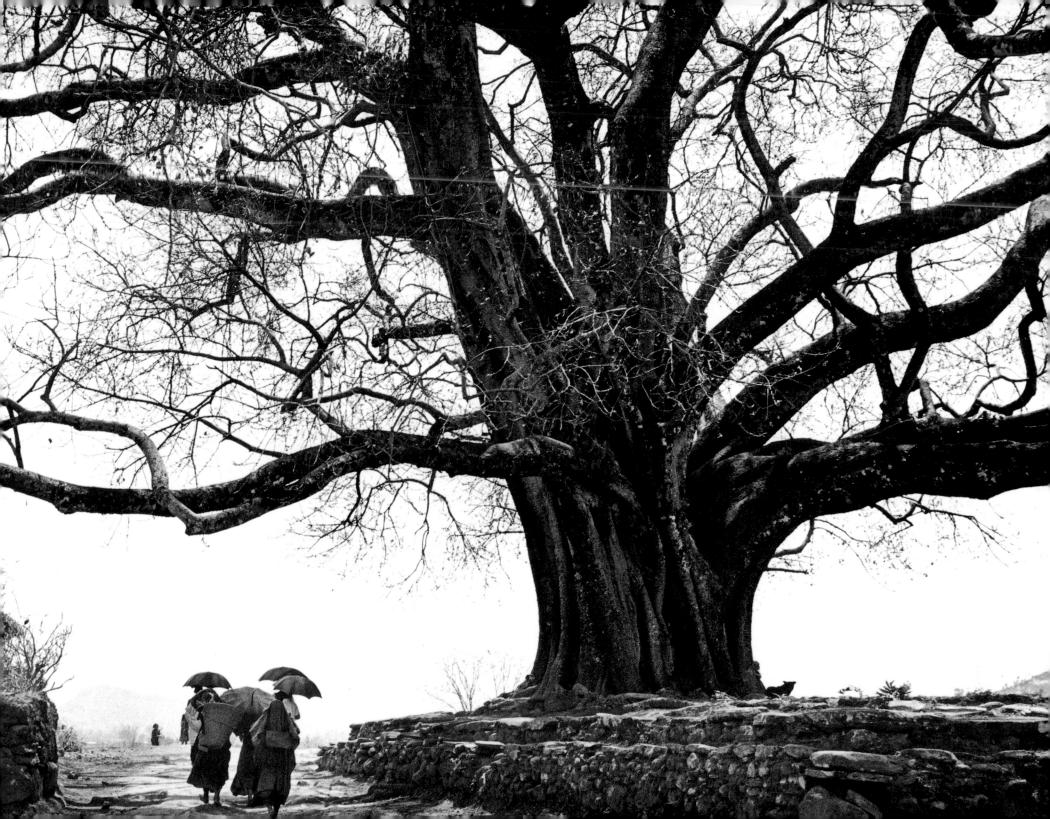

I like to work alone when hunting with a camera; infinite patience is needed. Others seldom share the uncanny feeling that something is about to happen, and impatiently want to move on.

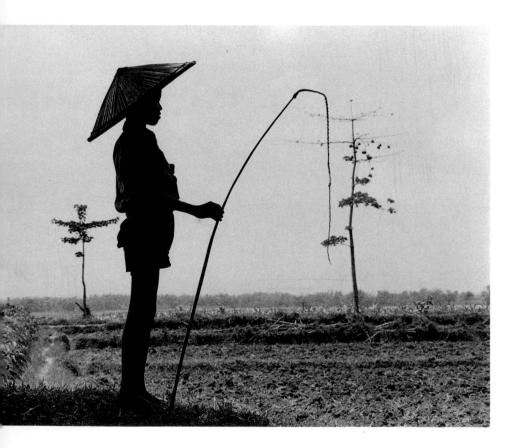

Java, Indonesia

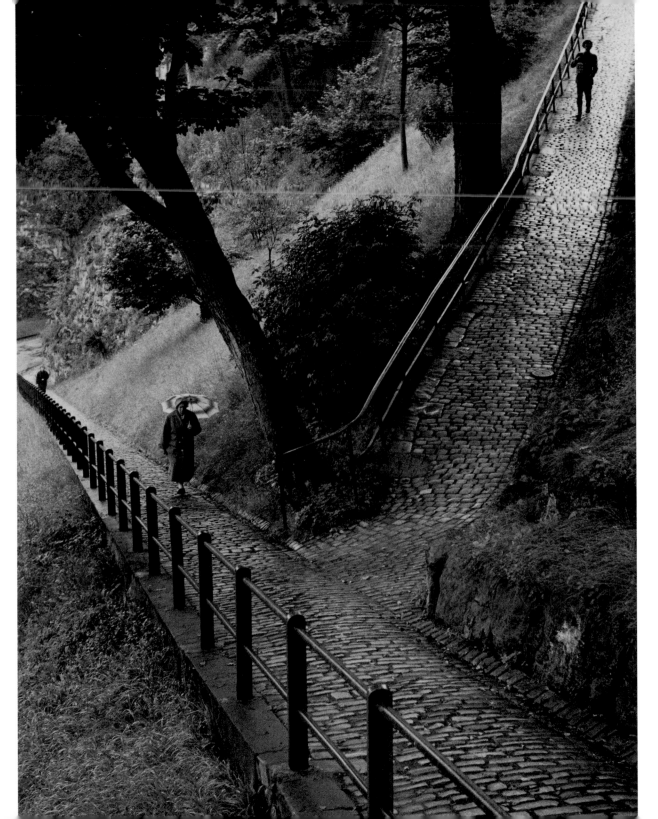

Luxembourg

After deciding what I wanted to say with my camera, I would proceed as quietly as possible to gather the story—never allowing myself to interfere with the subject.

Shiraz, Iran

Boston, Massachusetts, USA

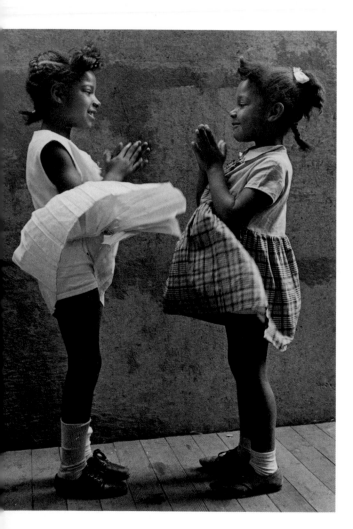

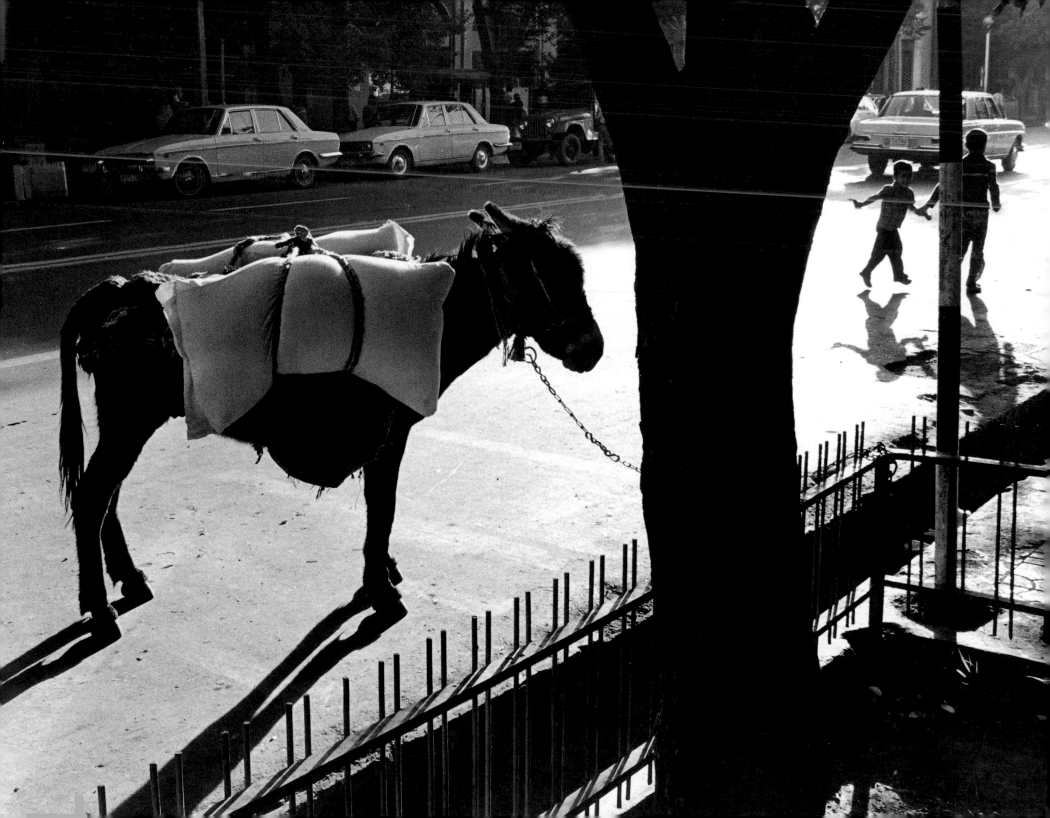

Watching a town come alive in the morning is one of the best ways to find good scenes and the good light necessary to capture them on film.

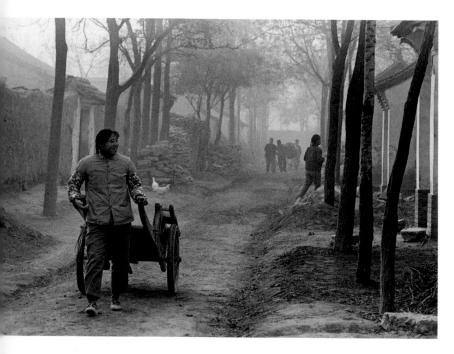

China

■ It wasn't even 5:30 a.m., but on the streets of China the day had already begun. As usual, I was up and about because being there at that time was the only way to see the informal faces of the Chinese. I photographed much of China in the morning light.

In Chongqing, the shores of the Yangtze River looked to me much like a disturbed beehive—junks, ferry boats, and barges all demanding docking space at the same time. Steady streams of passengers loaded and unloaded the waiting vessels piled high with foodstuffs, machines, and farm equipment.

In Peking [Beijing] and Shanghai, I watched the sidewalks become the extended homes of the working class. Mothers started small fires for the morning meal, braided their daughters' long black hair, and brushed their teeth at the curb. Fathers split wood, repaired bikes, and sat down to bowls of rice porridge. Older girls ran off to the neighborhood stores to buy freshly cooked, deep-fried crullers. Boys started games of chess. Aunts scrubbed and hung the laundry to dry on long bamboo poles.

And Chinese of all ages exercised—twisting, turning, bowing, swaying, and dancing—in slow, ballet-style movements.

Then, once the morning activities were complete, they all commenced to pedal off to work. The streets became a sea of honking buses, trucks, bicycles, pushcarts, wagons, water buffalo, tractors, and human beings laden with cargo.

In the early morning light I captured a China that was awake and on the move.

Shanghai, China

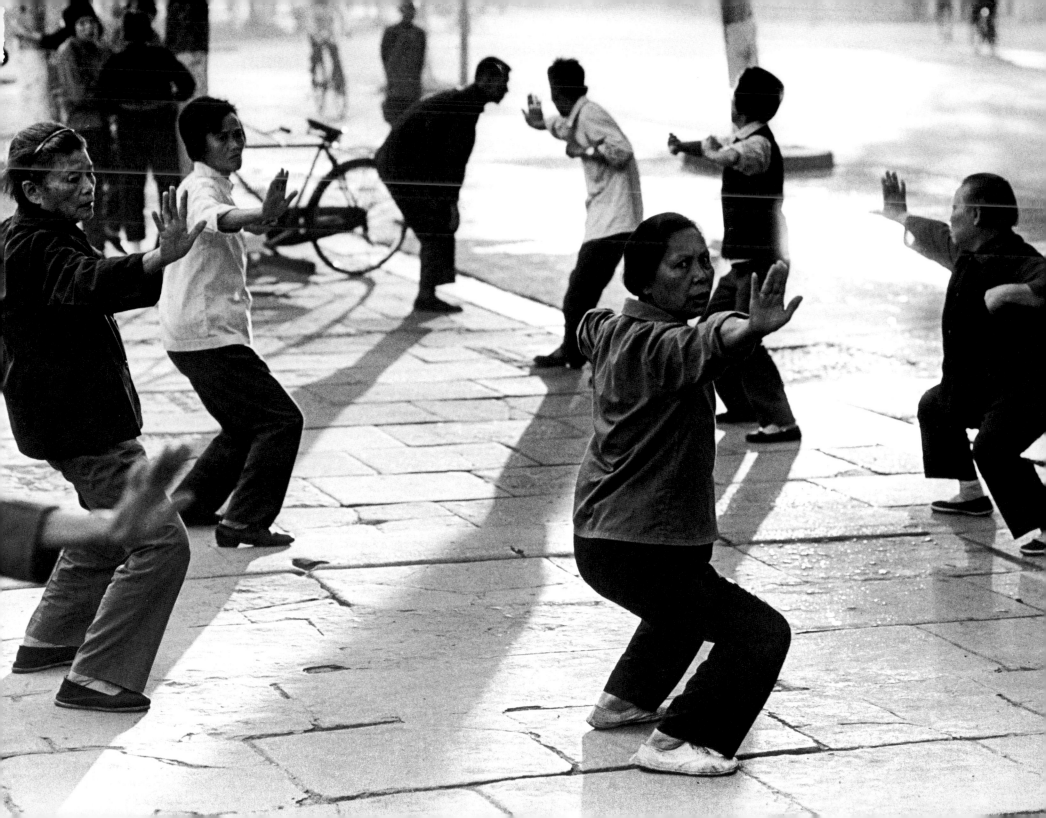

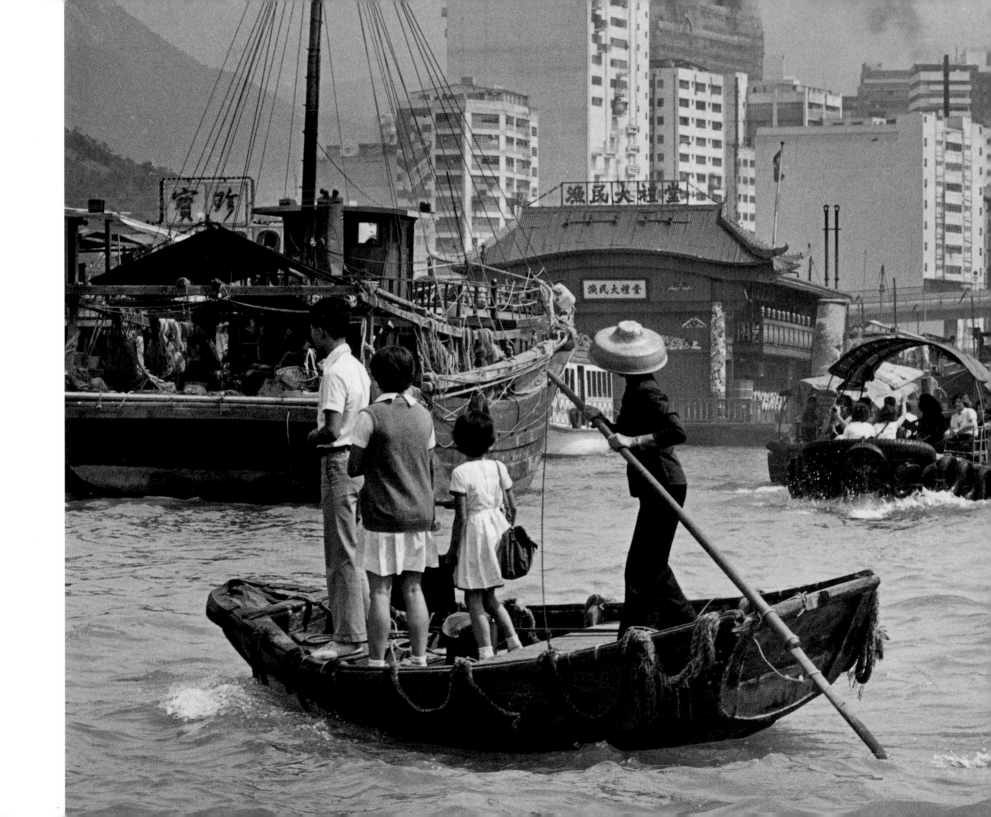

China

My favorite style of photography captures events unfolding in a normal, natural way.

Greenland

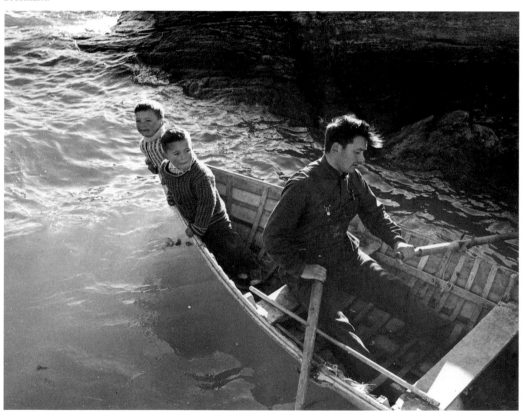

Mauritius

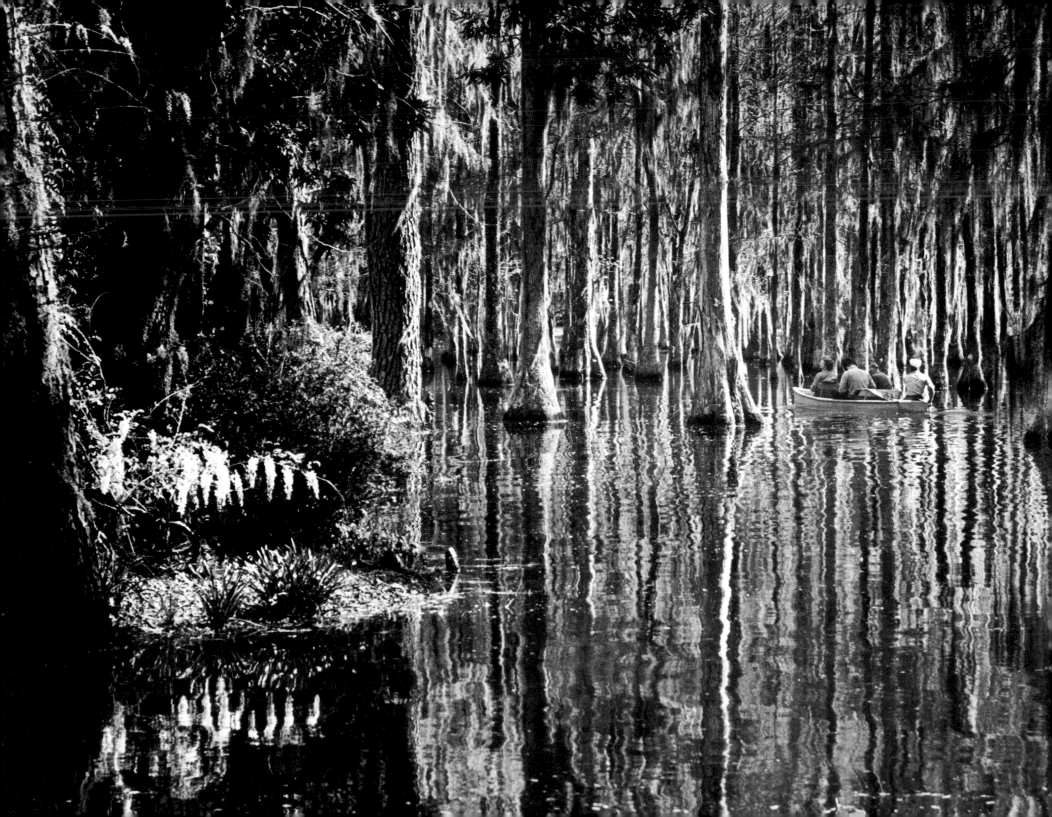

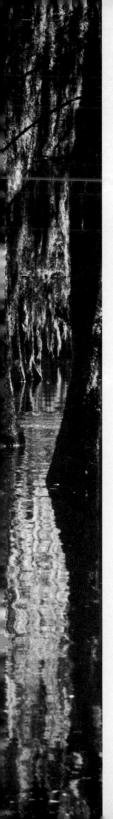

Some nature photographers today, as well as those of the past, find it unnatural to have people in their scenes. It all depends on why you are taking the photograph— what sort of statement you are making with your camera.

South Carolina, USA

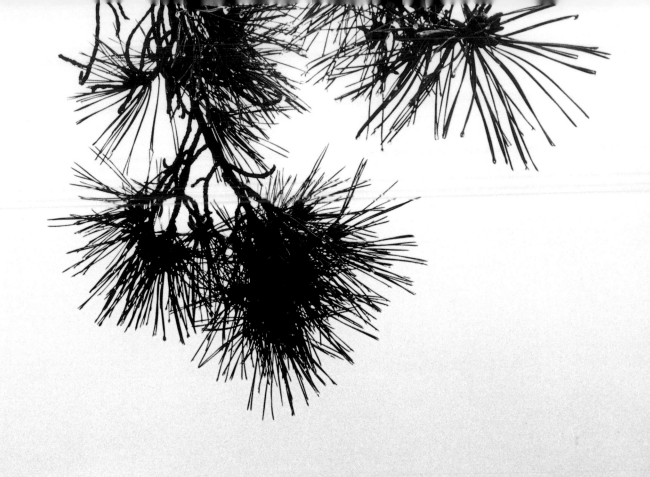
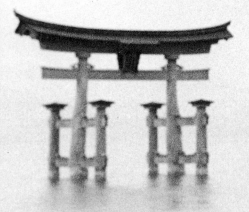

Japan

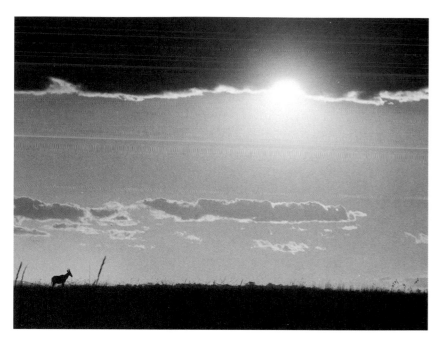

Many times I have used other forms of life or move-ment to complete pictures, such as animals, the movement of air, water, or clouds.

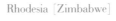

Rhodesia [Zimbabwe]

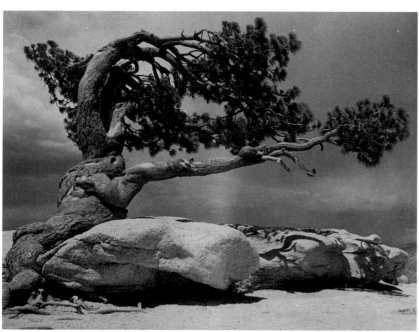

Yosemite National Park, California, USA

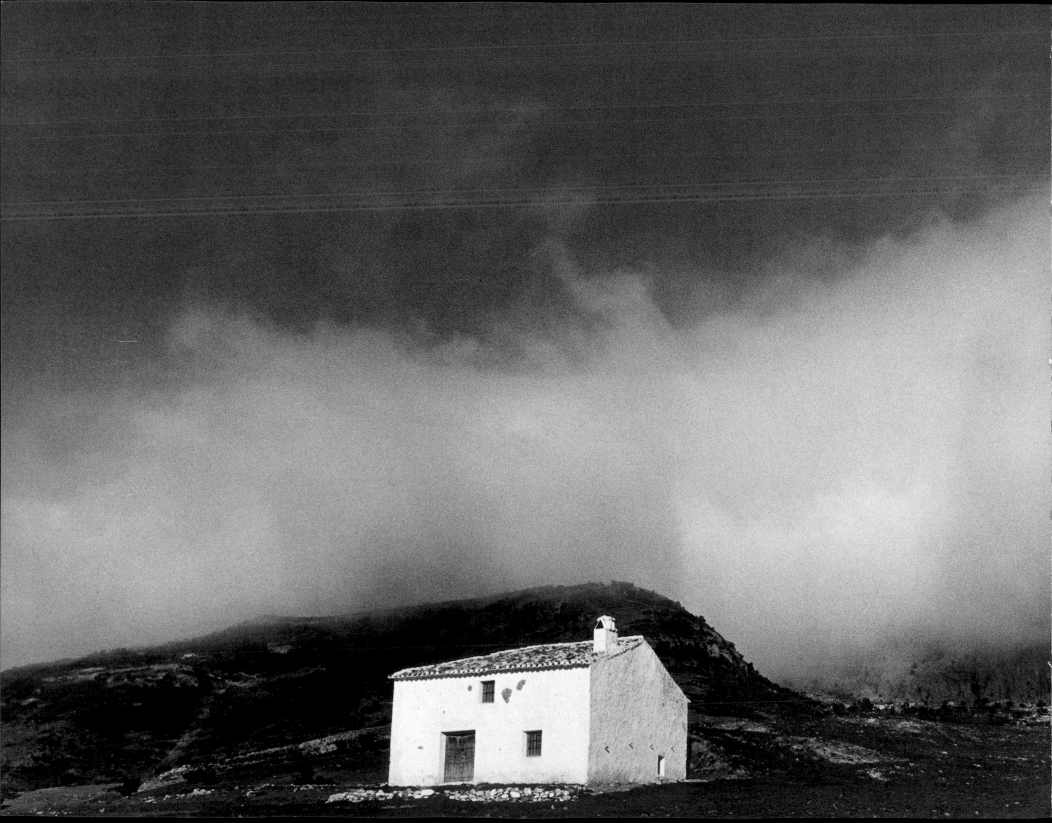

Soft light allows the photographer to work freely from all angles without the worry of deep shadows or strong contrast.

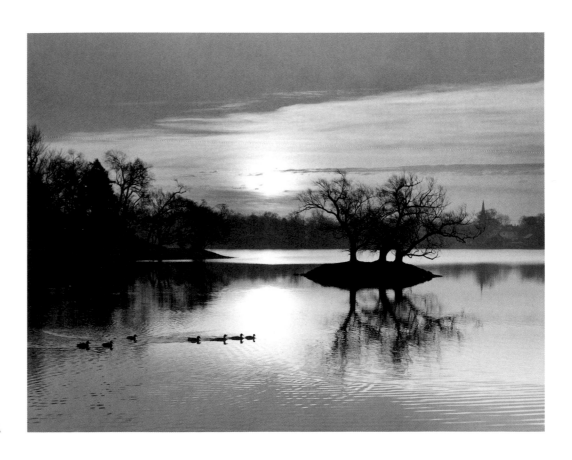

Boston, Massachusetts, USA

As a candid photographer whose general purpose was to communicate with people and bring a greater understanding between peoples of the world, I usually worked figures into my photographs.

Kashmir, India

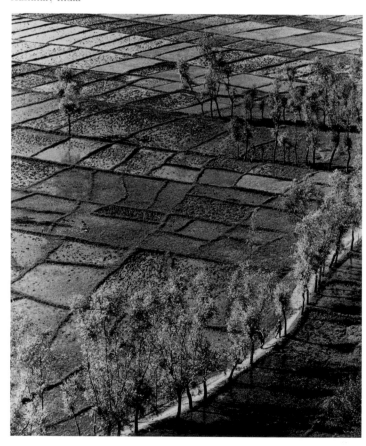

Baghdad, Iraq

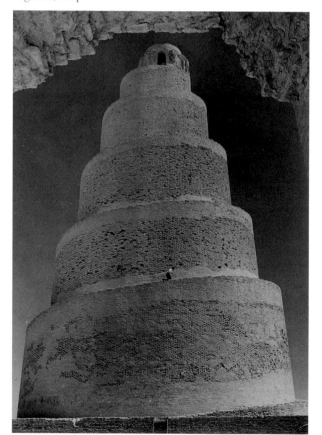

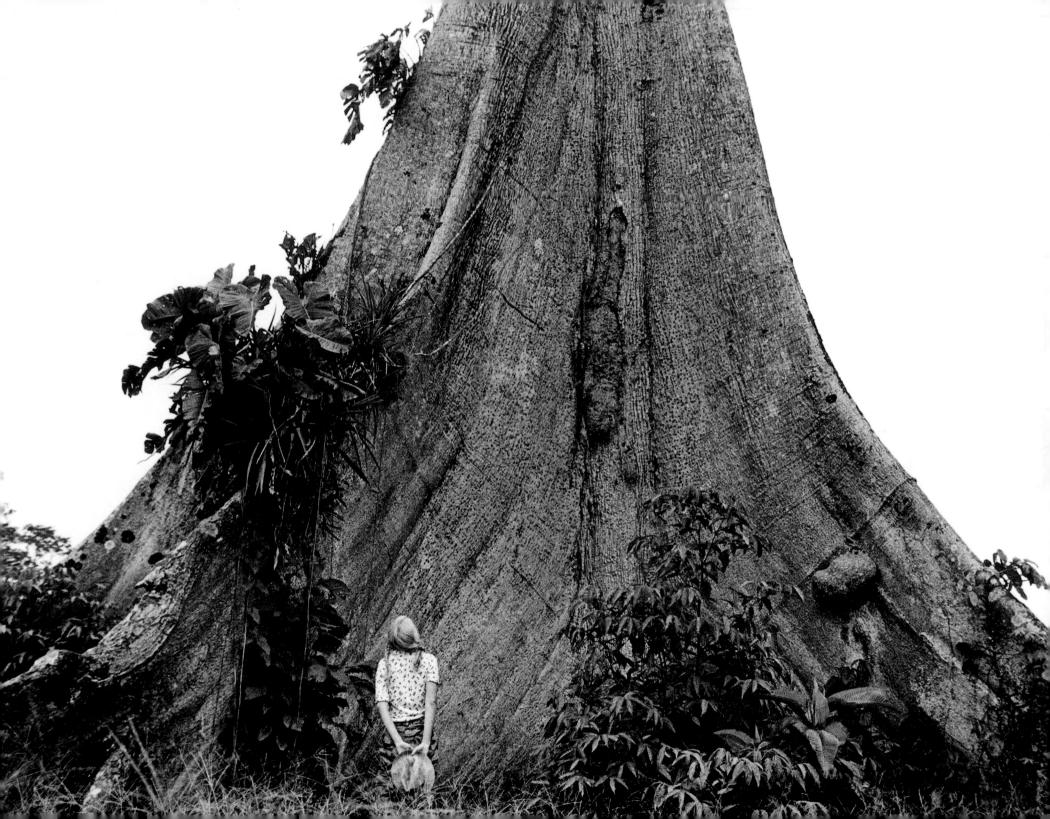

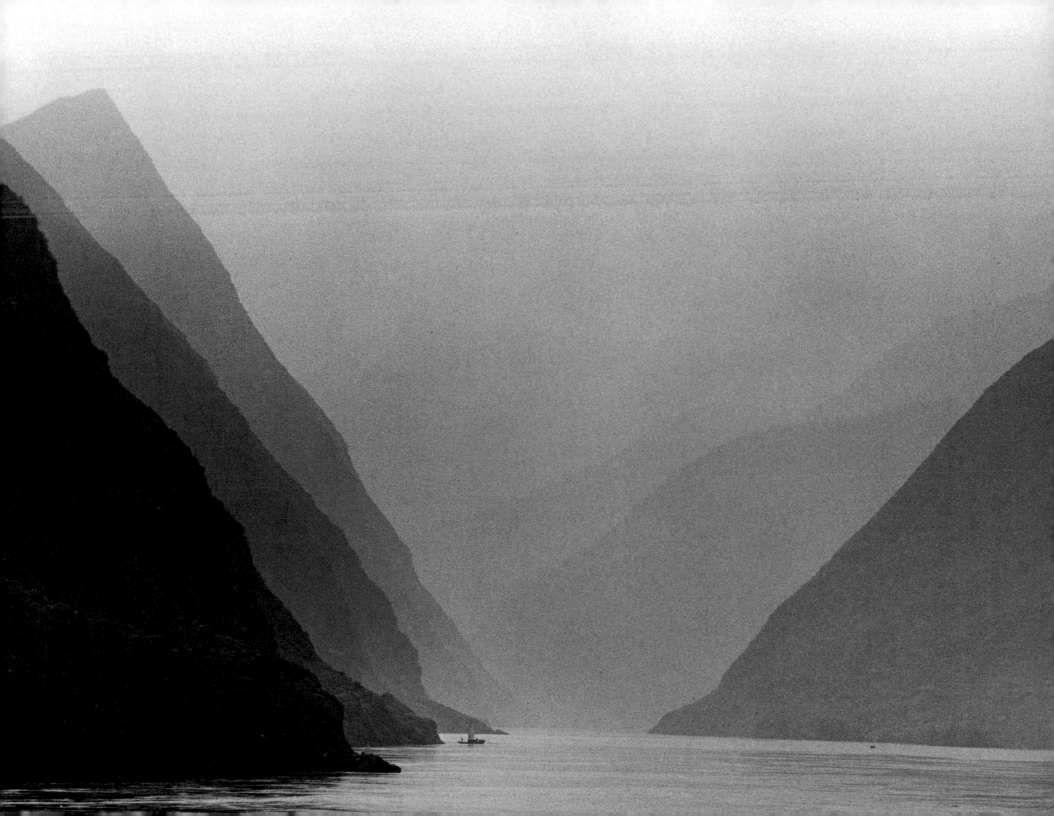

■ I have a deep respect and admiration for Ansel Adams, the late photographer and conservationist. I'll never forget the true zest for life that he exhibited throughout his career. As a photographer, he mastered the basic problems of space, light and scale. He knew how to capture the infinite nature of life onto a single piece of film.

I once spent four or five days with him as he conducted his yearly course in Yosemite National Park in California. Every summer he led a group of students, both advanced amateurs and professionals, through the park, loaded with many large viewcameras, tripods, quantities of film, filters, exposure meters and black focusing cloths.

It was fascinating to be with him and watch Mr. Adams help his students discover the world around them. He patiently worked with them. He expressed genuine excitement in watching them learn. He was thrilled, as if he had never been there before, even though he had been there hundreds of times.

What impressed me most about Mr. Adams, I think, was that in addition to being a master-photographer, he also excelled in so many other areas of endeavor. He was an accomplished chemist, writer, teacher, musician and philosopher.

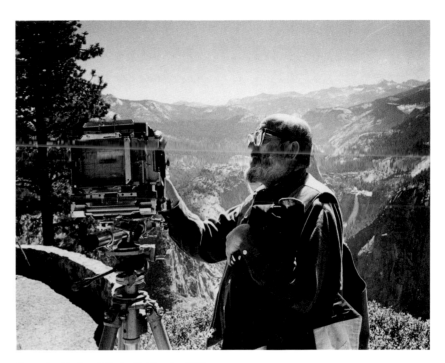

Yosemite National Park, California, USA

La Paz, Bolivia

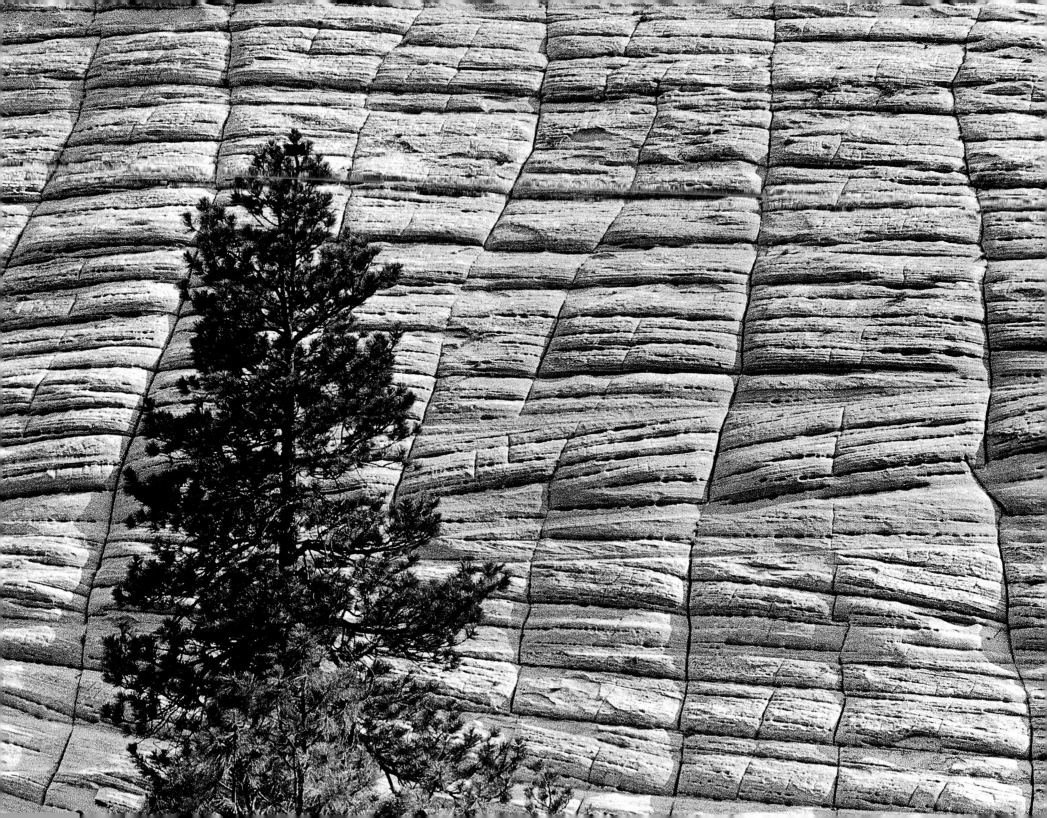

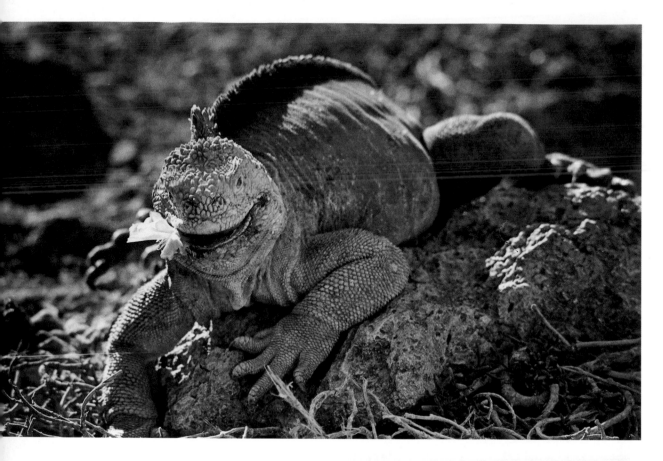

■ There they were . . . an awesome sight. They looked far more like giant clinkers fused together than islands in the Pacific.

A longtime wish was coming true; I was about to step ashore on the Islands of Galapagos, 600 miles off the coast of Ecuador. Here I would see giant tortoises and lizards, rare birds, and flora found nowhere else on earth today. The animals here have no fear of man, and you can enter their world completely unnoticed.

As we approached by boat we could see living creatures everywhere. Blue-footed boobies flew in the skies above; seals swam in the waters below; enormous, ugly-but-beautiful iguanas swarmed the black volcanic shores.

Scattered over a 36,000-square-mile area, the islands are well separated from one another, and all are quite isolated from the rest of the world. Thus each of the islands has different plants and animals. For this reason, I visited many of them.

Galapagos Islands, Ecuador

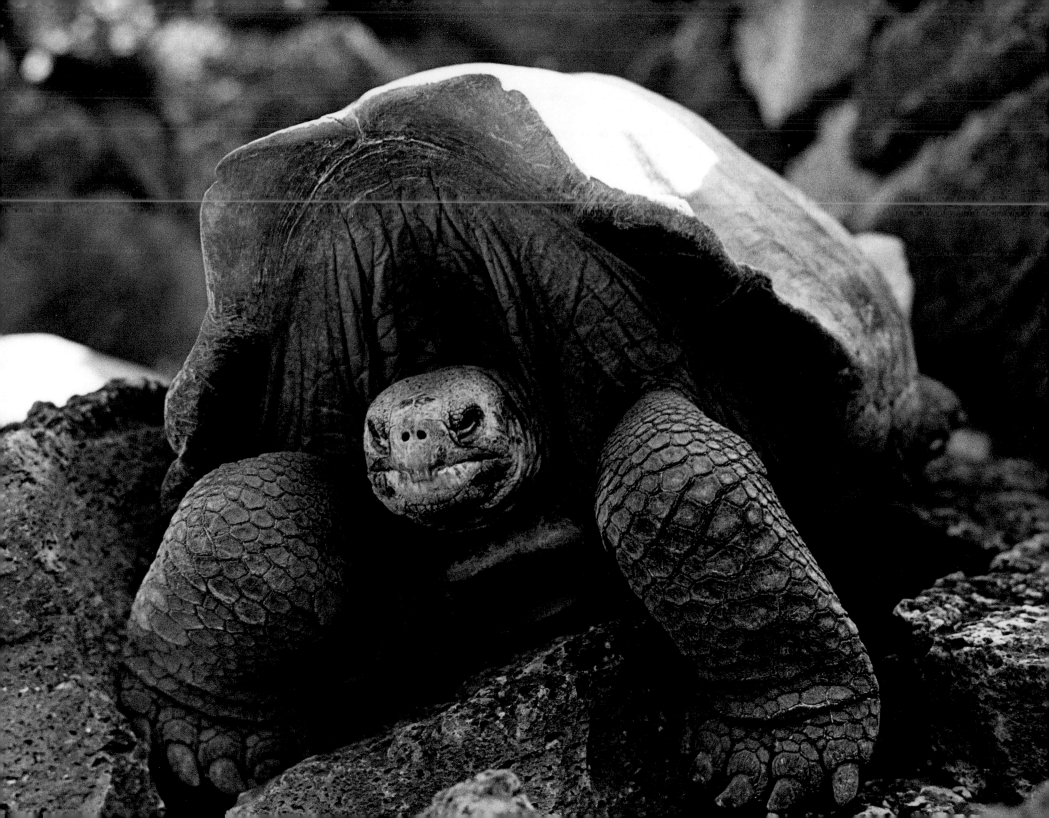

San Diego, California, USA

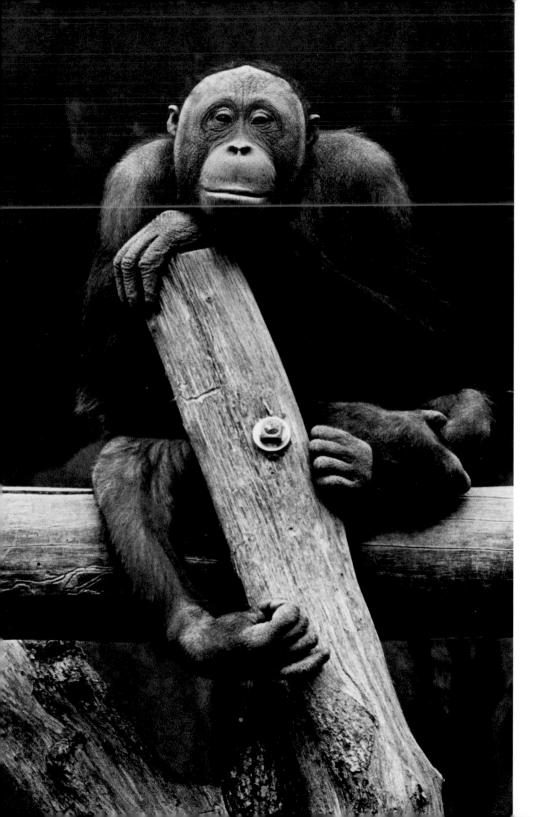

When visiting zoos, I have always found my best material early, before the morning feeding. Dusk is another excellent time, when the heat of the day is over and the little ones begin to play.

Stokholm, Sweden

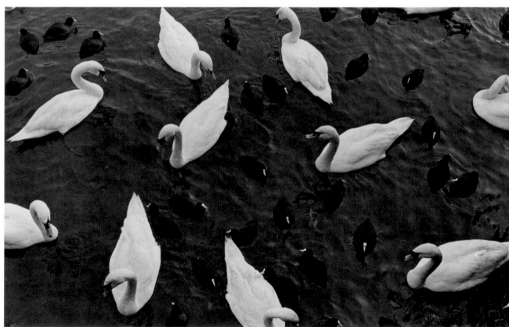

Needham, Massachusetts, USA

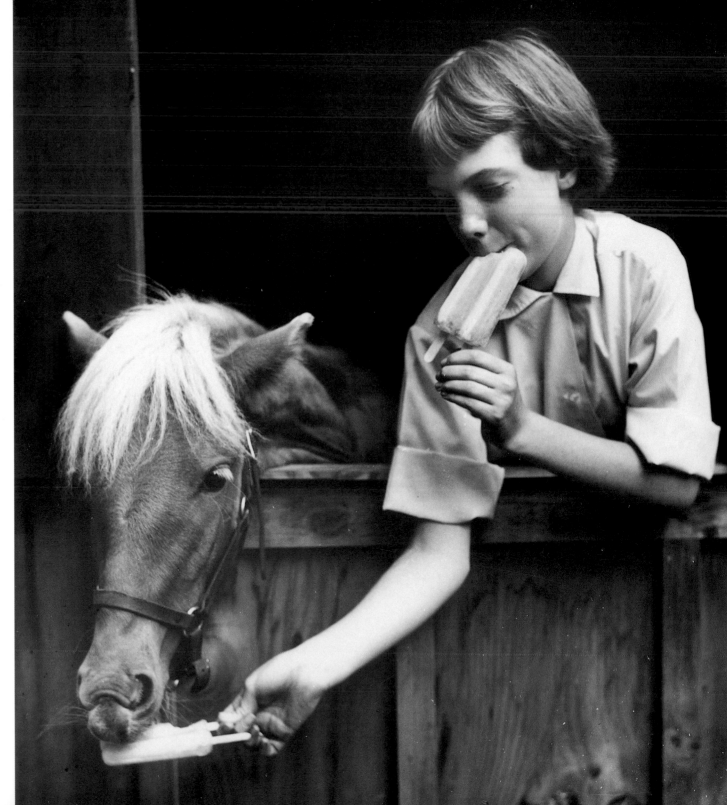

Needham, Massachusetts, USA

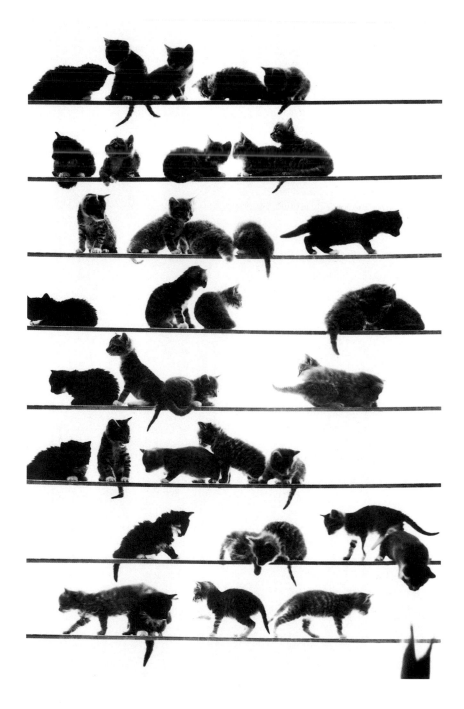

■ The photograph of all the kittens was a multiple exposure that took a great deal of time to execute. One afternoon I noticed our new litter of five kittens playing on the top of a fence—too spread out for a photograph. I enjoyed seeing them in action and decided to place them on a flat board laid over the back of two chairs. I then silhouetted them in front of a white sheet. The only way to truly show all their cute actions was to take a multiple exposure in this way. It didn't happen quickly, but the results paid off. Just at the point when I wondered how to finish the photograph, the last kitten provided me with a solution.

Needham, Massachusetts, USA

■ People ask if it is necessary to invest hundreds of dollars to take presentable photographs. The answer is: definitely not. Even the most inexperienced photographer can obtain good and often excellent results. The person behind the camera is always the most important factor.

Any camera, regardless of cost, is only a tool. Too many people "talk" photography, yet seldom have results to display. Many enjoy the mechanics of photographic equipment more than they do picture-taking.

To me, equipment should become automatic in use. Whether your equipment is a camera or an automobile, it is only a means to an end. Just as you no longer have to "think" about walking or driving a car, you should not have to "think" about your camera. Like any good tool, learn to use it automatically and spend the rest of your time concentrating on the end result . . . excellent photographs.

The best rule I know for becoming more professional is to carefully show only your very best work. As for the rest, examine it alone in the darkroom, note your mistakes and eventually destroy it. Too many of us have been put to sleep with hours and hours of color slides, shown by a well-meaning friend. My slide shows never last more than one hour.

Good books and magazines can supply you with photographic rules. Digest these rules carefully, and then start breaking them whenever possible . . . with wisdom and thought. Nothing new has ever been accomplished by doing what everyone else has done.

Learn to experiment. Never take a full roll of pictures without saving a few frames for new ideas. Why do beginners often take their finest photographs while handling a camera for the very first time? Because no one has told them what cannot be done.

It is helpful, too, to think of a photograph as a reflection of one's own thinking. Reasoning along these lines, you should find that your work will rise out of the snapshot class and into the prizewinner category.

A photographer must mentally see any picture before recording it on film. Professionals usually have very clear ideas of what they are attempting to say on film before they start to shoot. The clearer the idea, the clearer the picture. They start forming central ideas first, and then give them form, shape and color with the camera.

Many camera enthusiasts today work only with color. It is, without question, beautiful to work with and has tremendous visual impact. Yet, I prefer working with black and white. It dramatically conveys fact and feeling with its own very special force. One should learn to work with both, specializing in the medium he or she enjoys the most.

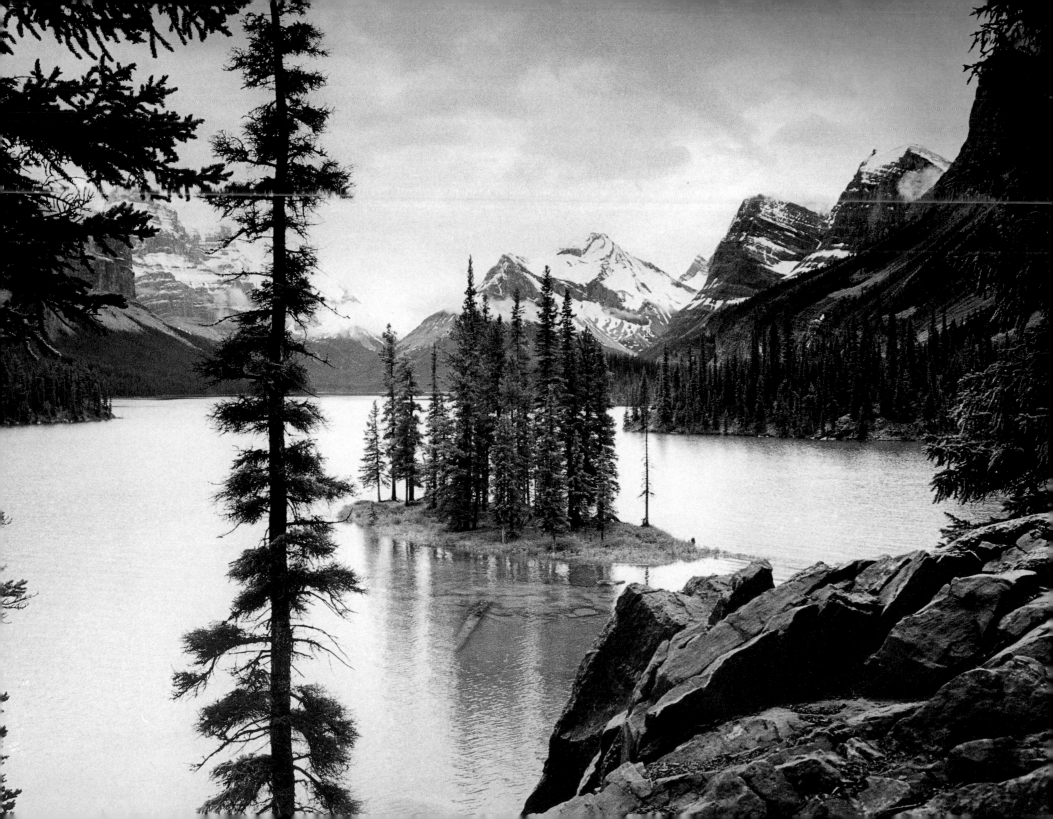

A perfect picture doesn't happen every time you click the shutter, no matter how good a photographer you are. I always knew when I had taken a good photograph. There wasn't any need to wait for the film to develop to know what the outcome would be—I could feel when all of the elements had come together.

Concord, Massachusetts, USA

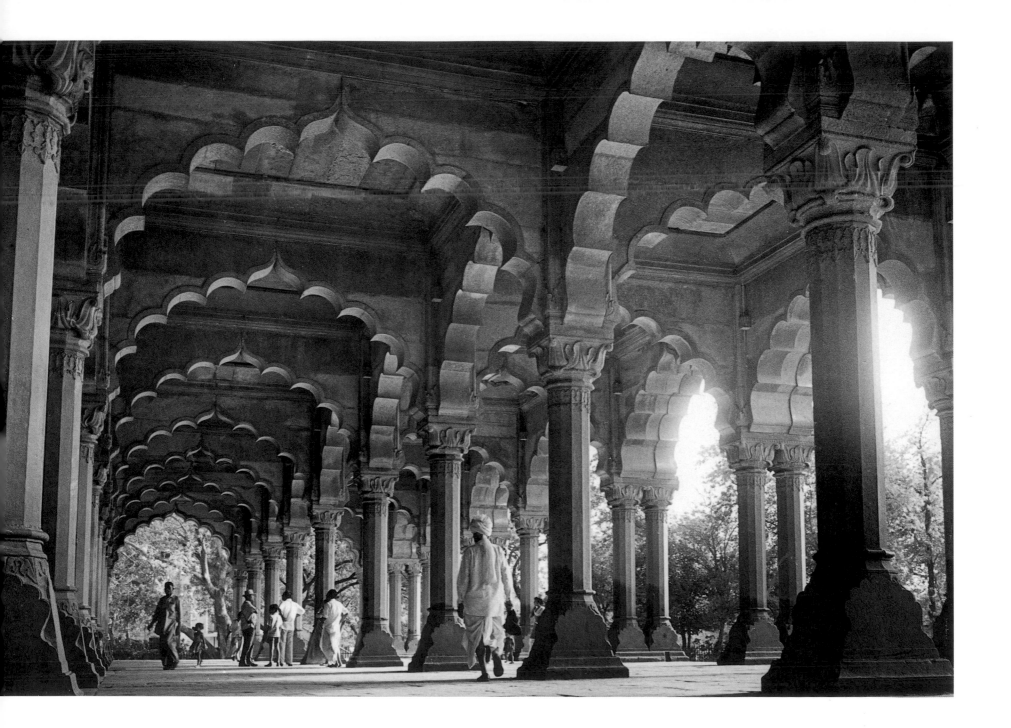

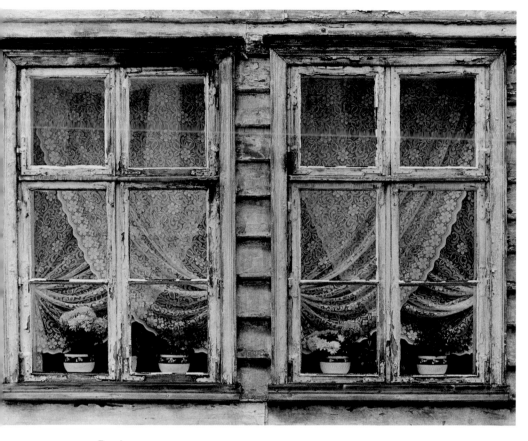

Russia

Most mentally active photographers are continuously taking pictures. They are always evaluating form, shape, color and texture as it comes into play with shades of light and darkness. In a world of movement and change, they think in visual terms. They attempt to freeze bits of life as it unfolds before their eyes.

Old Delhi, India

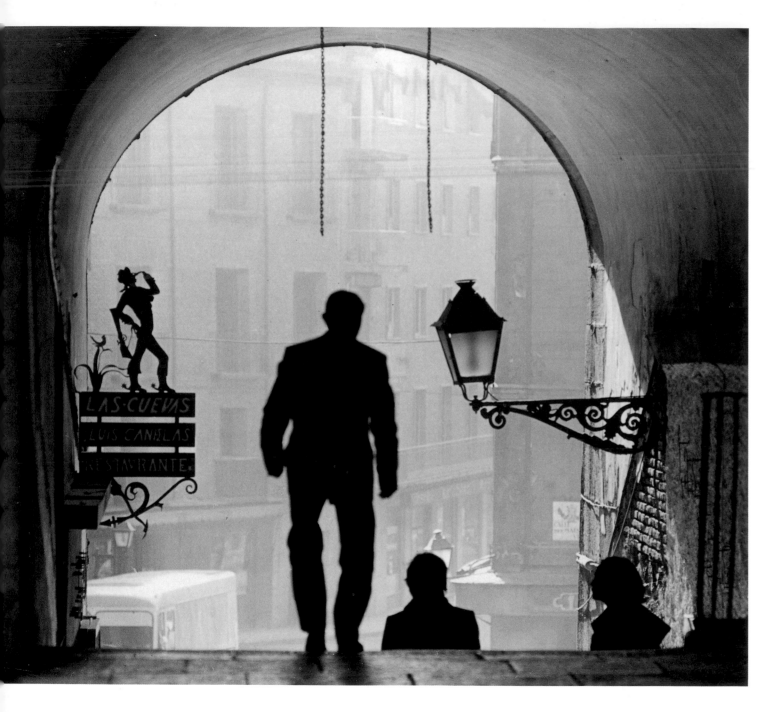

Madrid, Spain

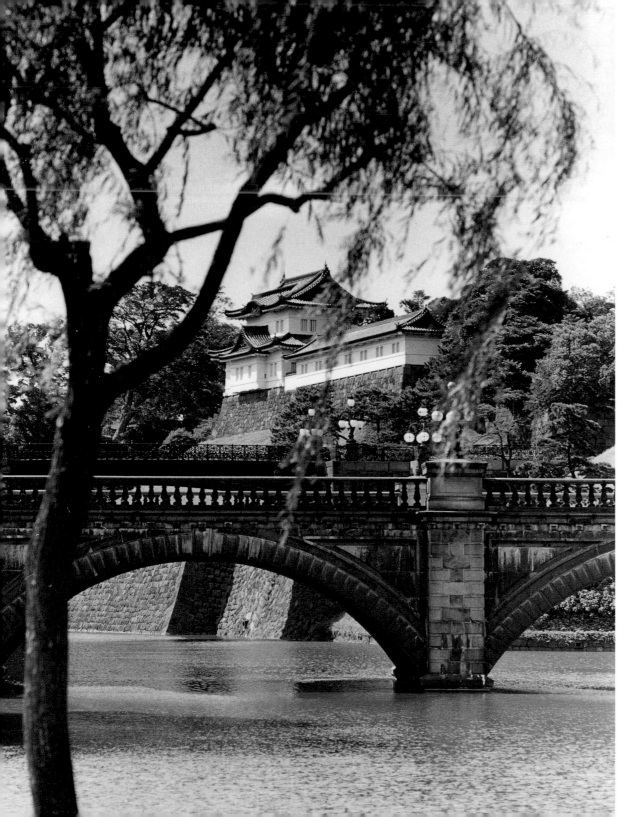

Deerfield, Connecticut, USA

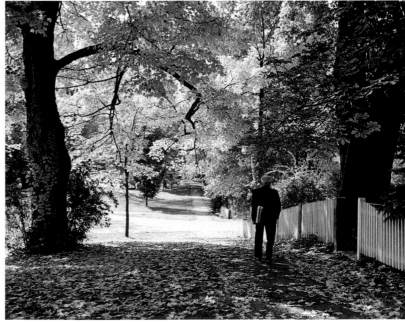

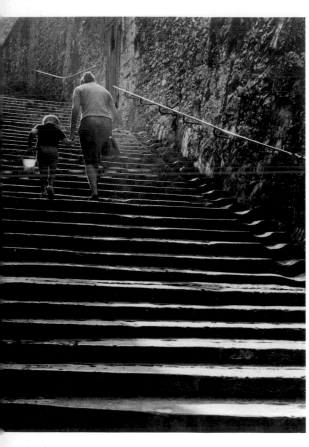

Blois, France

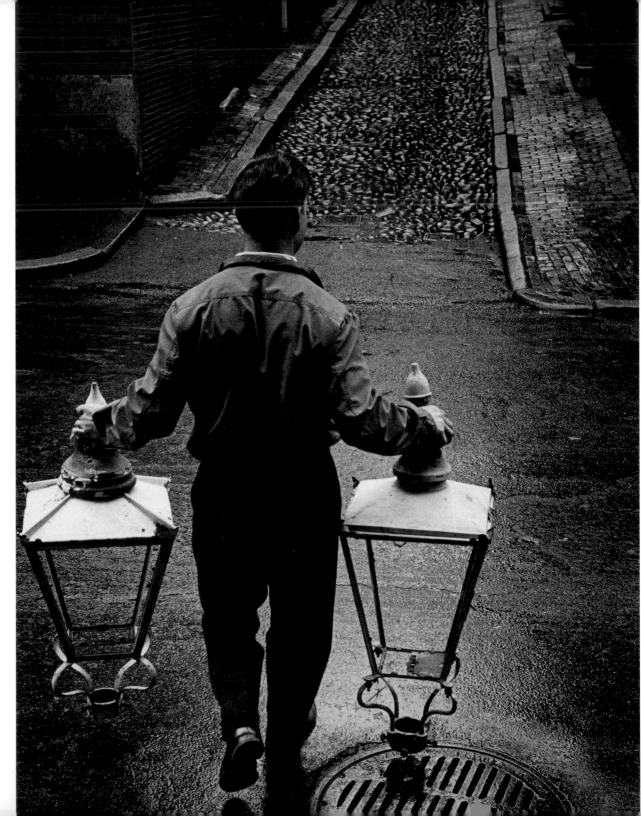

Boston, Massachusetts, USA

China *facing page*

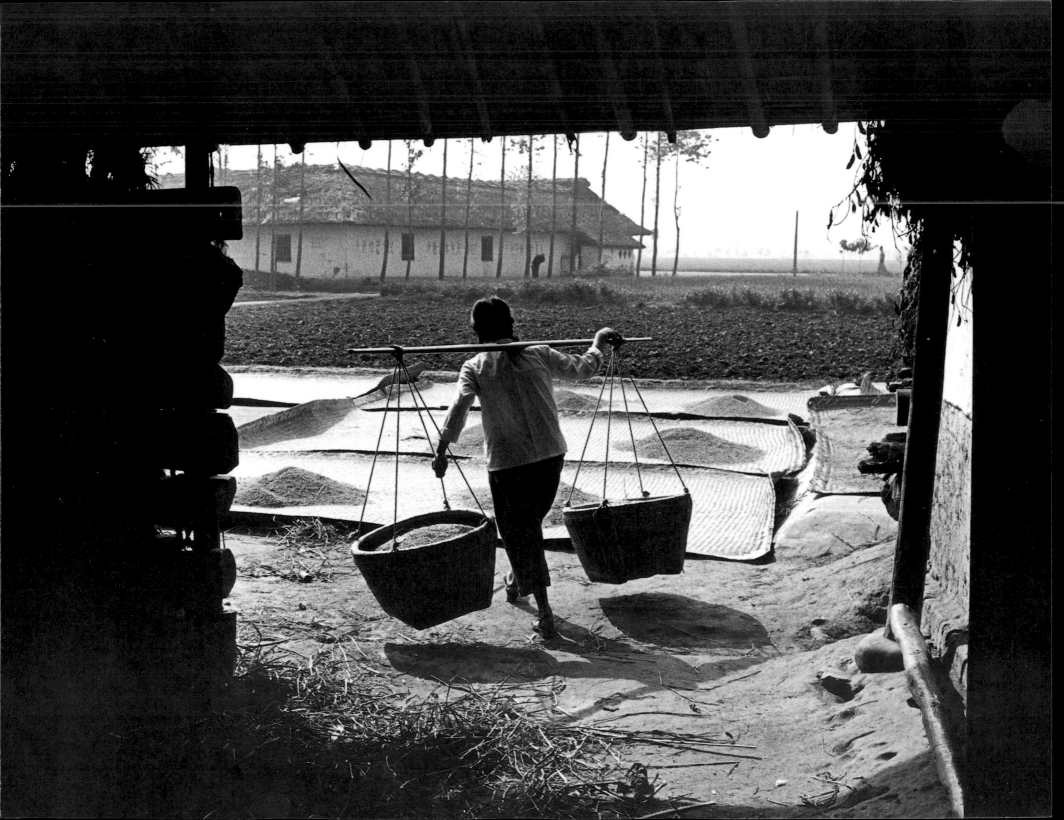

*Thought should be completely on the subject matter.
The mind, the eyes, the heart and the
camera must all work together,
uninterrupted.*

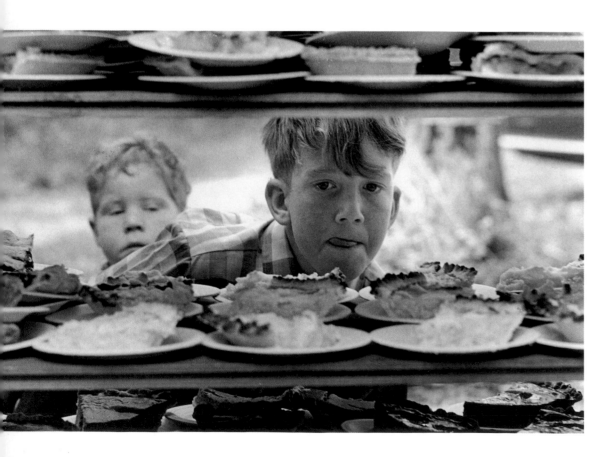

Cape Cod, Massachusetts, USA

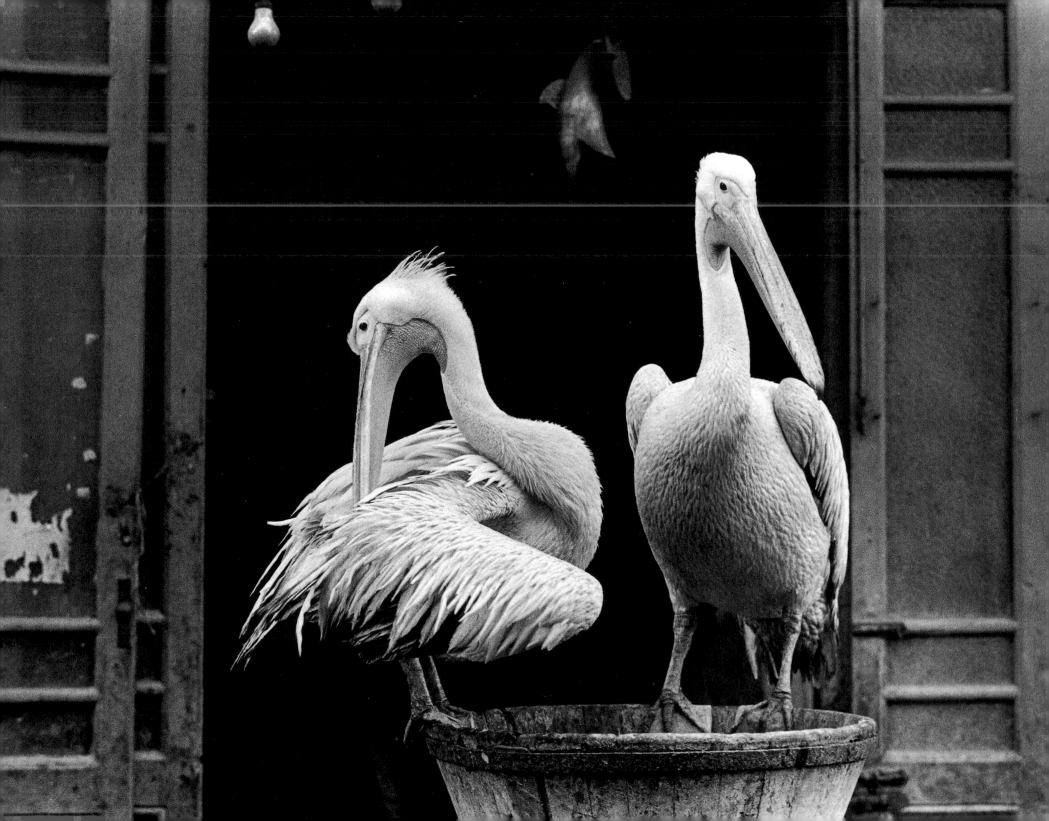

I believe serious photographers would agree that what moves the amateur into the professional realm of visual communication is the "process of thinking" that goes on behind the camera lens.

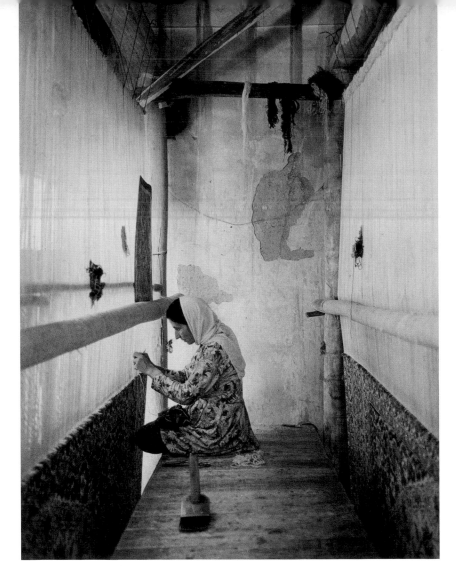

Iran

Boston, Massachusetts, USA

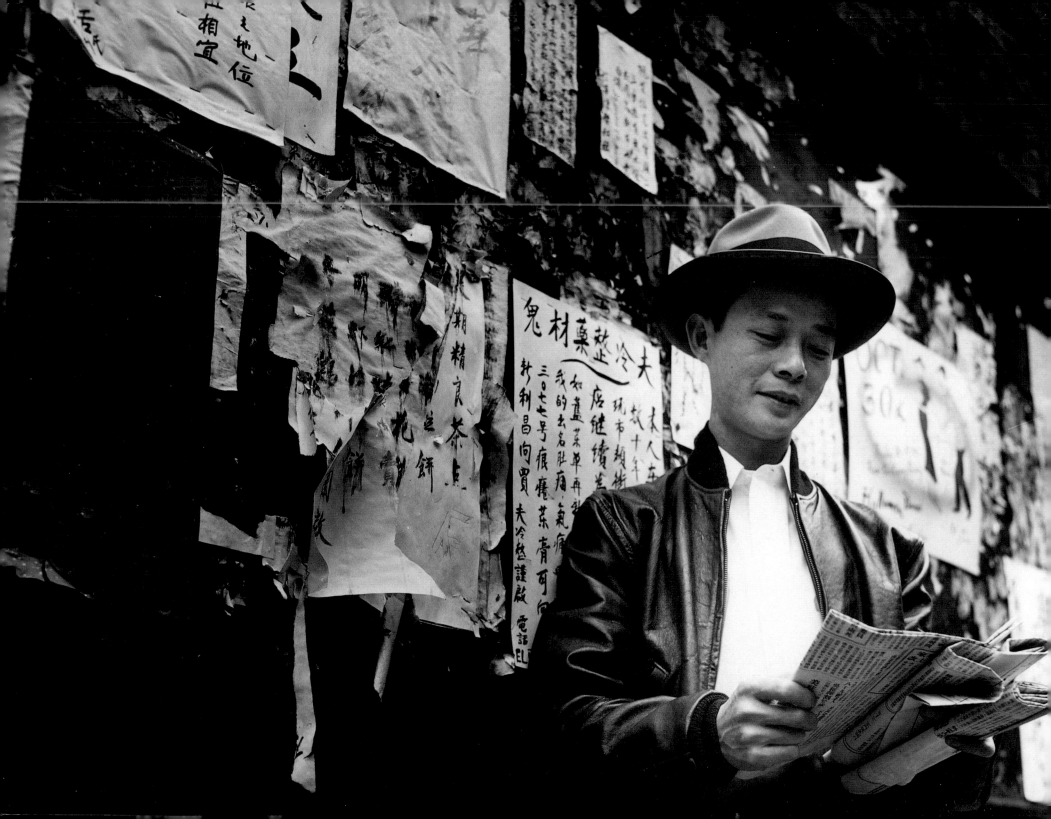

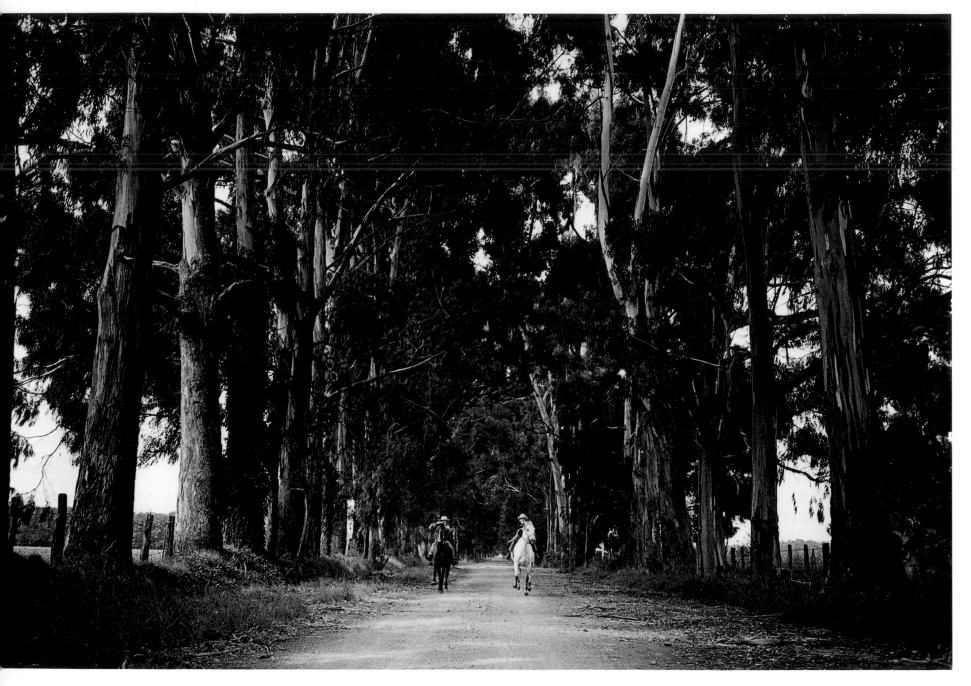

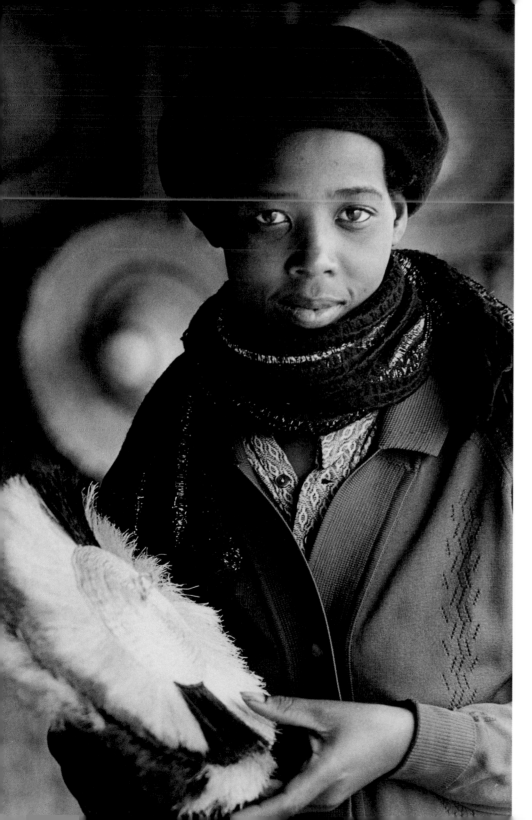

South Africa

Good photographs, like good writing, are very personal statements of thought. A set of photographs usually reflects the artist's interests and feelings. They register an intimate relationship between the photographer and his subject. The viewer only shares this experience, reading into it whatever he or she wishes. Some will accept the work, others will reject it.

I took pictures all the time, whether or not I was actually "on the job". Some of my best pictures were taken on my own time rather than during work hours. If I saw something interesting, I accepted the challenge of putting it onto film and re-cording it for others to see.

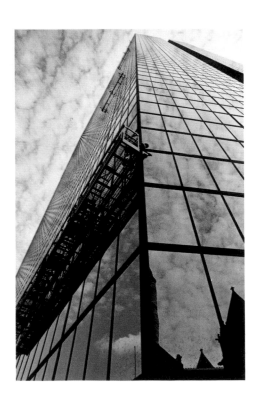

■ Once on a walk past the John Hancock Building in Boston, I was compelled to look up at the huge glass walls. The tower seemed to constantly change in mood as it reflected the clouds and sky in its 13.5 acres of glass.

I noticed the long, narrow window-washing platform that had been lowered down the side of the structure. After taking a photograph or two from the sidewalk level I found myself wondering what it all must look like to the window-washing crew from its starting point at the top.

I figured that the platform must extend at least 20 to 25 feet out from the corners of the building as it clung to tracks at the very edge of the roof, and I asked if it were possible to stop the machinery at that point. Finding it could be done, I ventured up and out with a window washer and a security guard.

It would have been so easy to shoot over the shoulders of the window washer in a normal way, but I would have recorded mostly offices and sky. To get the downward view that I was after, it was necessary to get into a yet higher position. Locating an ash can the cleaners used for dirty rags, I overturned it and climbed on, placing one foot on it and the other on the rail. Thanks to the strong arms of the security guard who held me by the waist, I captured the photo I was after . . . straight down.

Boston, Massachusetts, USA

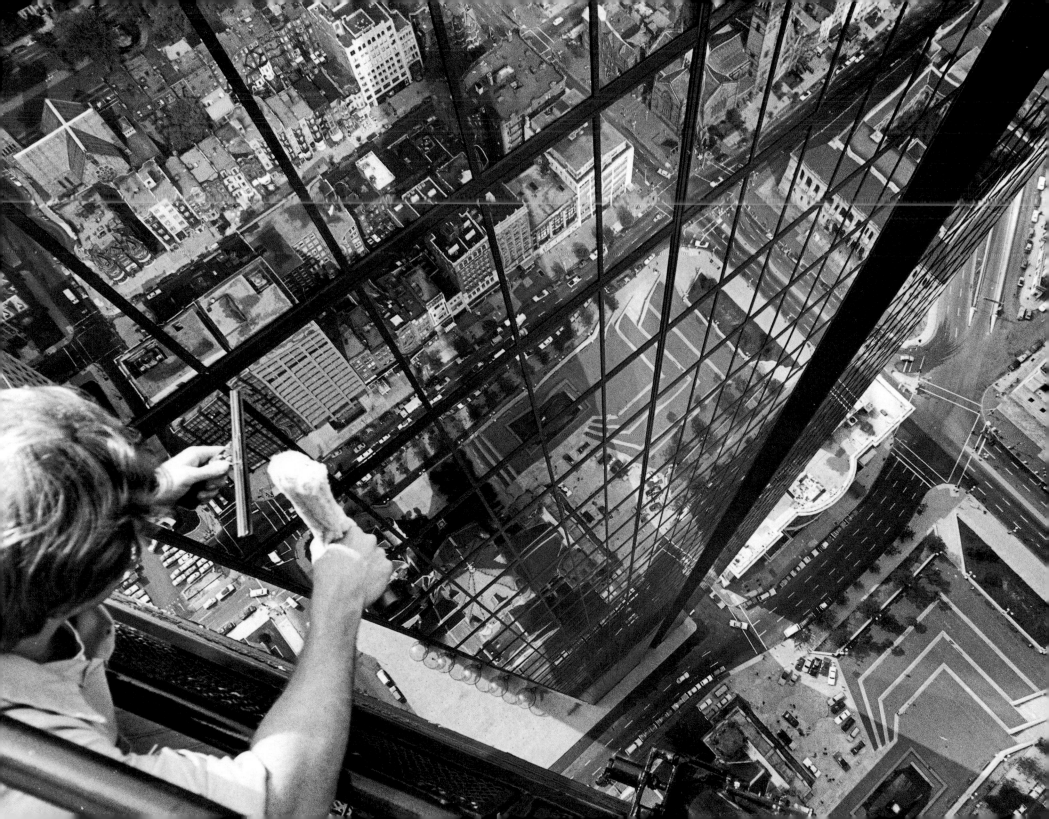

Brookline, MA, USA

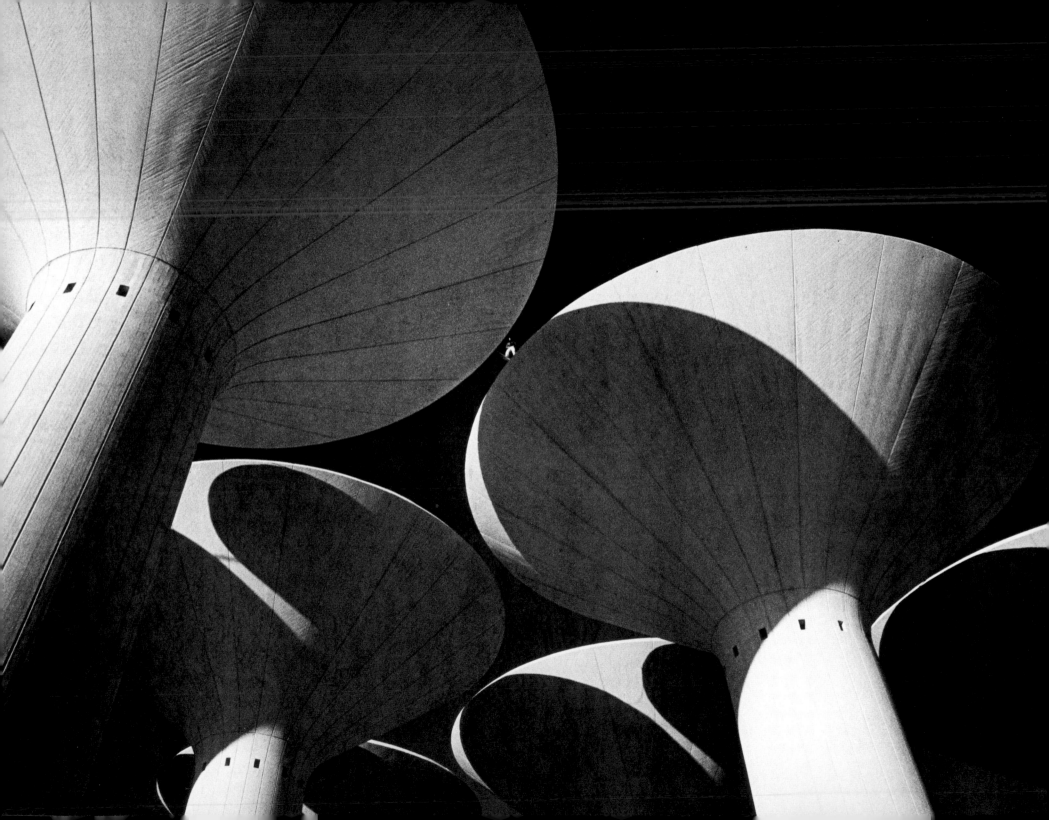

I considered an assignment to be successful if I could not wait to get back to the darkroom to see the results. I have always enjoyed doing my own darkroom work as it gives me an opportunity to carry out my own ideas to the end.

■ Not until I was developing this picture of water tanks in Kuwait did I notice that there was a person in it. A man had put a plank across from the top of one tank to the next, and was walking across. He was about as big as a mosquito, and I had been so absorbed in observing the shapes of the tanks that I didn't even see him.

In the darkroom I darkened the sky so that he stood out better. This man provided a third element, in addition to the tanks and the sky, that gave the picture a whole new dimension.

Kuwait

I was one of the first newspaper photographers to begin using the 35mm camera in my work. There was a prevailing thought that this camera was too small and the film too slow for newspaper work.

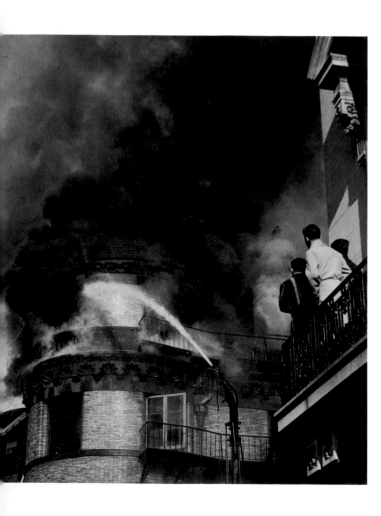

■ I noticed that magazine photographers were producing better work with 35mm cameras than the newspaper people were with their Speed Graphics. I started using the 35mm because I wanted to bring a more spontaneous approach to photojournalism. That probably had a lot to do with my winning the Newspaper-Magazine Photographer of the Year Award in 1959.

An experienced photojournalist is never without a camera. You never know when you'll suddenly have the opportunity to record an event, and you want to be ready whenever it comes. I took this picture on my way to work in the car one morning, with no warning at all.

Boston, Massachusetts, USA

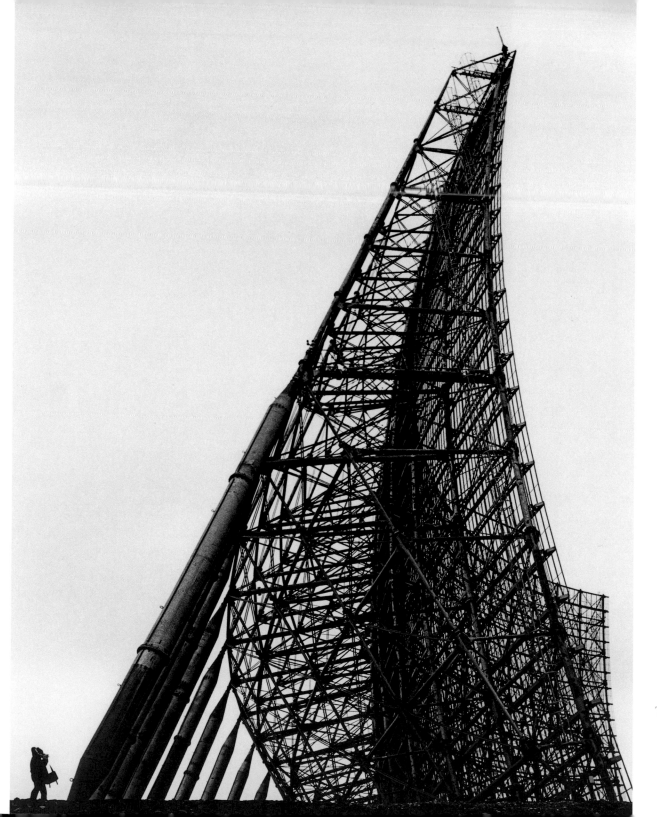

Thule Air Base, Greenland

■ After I'd been photo editor of *The Christian Science Monitor* for awhile, I began to feel that editors were cropping the photographs too severely and leaving important ones out of stories altogether. I felt the work wasn't always communicating what it should to the readers.

Finally, I said the photographs would have to be printed in the paper in the form I'd worked hard to achieve—in other words, untouched. I needed a forum for what I intended to show.

I was then given a full page spread each month to compose as I wanted, and I began to print collections of pictures on a particular subject—a news story or country or theme. These sections became popular, and we began to run them more and more. Now you see photo series like these more often in newspapers and magazines, but the *Monitor* was one of the first publications to start using them.

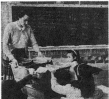

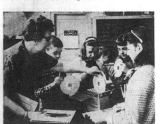
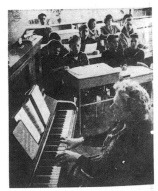

Second Section THE CHRISTIAN SCIENCE MONITOR Tuesday, May 10, 1960

'Musicmobile's Coming!'

Text by Carolyn F. Hummel, Staff Writer
Photographs by Gordon N. Converse, Chief Photographer

Softly, Altos, Softly!

Ding Dong! Music Time

And On to the Next School

Singing Lad

They Know What the Baskets Hold

Dreaming of Faraway Lands

Teacher and Driver Arrange Loans

Eager Helpers Tote the Records

Above: Vermont Songstress
Left: "Ooh, 'Swan Lake'!"
Right: Rehearsing for the Concert

Left Page

Second Section THE CHRISTIAN SCIENCE MONITOR Monday, August 2, 1965

Old and the new

JOURNEY TO EGYPT
WITH GORDON CONVERSE

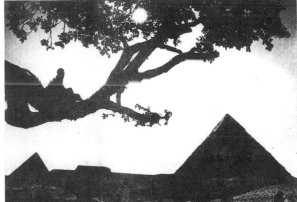

The great Giza pyramids along the Nile live on

A cradle of civilization

Egyptian youth

Known as a "cradle of civilization," Egypt has a recorded history dating back nearly 6,000 years. Achievements of the ancient Egyptians are still a source of amazement to modern scholars. The great pyramids and the Sphinx at Giza have stood under the blazing desert sun for thousands of years with little sign of deterioration.

The Nile, second longest river in the world, supplies the country with a transportation route and a thin stretch of green vegetation along its banks. Almost the entire Egyptian population lives along these banks. In many cases, the Nile villages have changed little, but the great city of Cairo is becoming one of the world's most modern cities.

Gordon N. Converse,
chief photographer of
The Christian Science Monitor

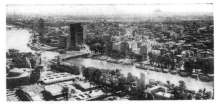

Modern Cairo spreads out from Nile shores

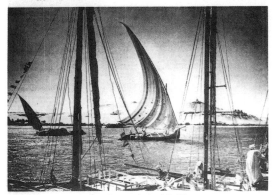

Along the upper banks of the Nile

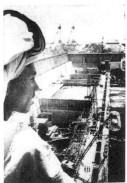

Aswan Dam under construction

Right Page

THE CHRISTIAN SCIENCE MONITOR Second Section Wednesday, March 25, 1970

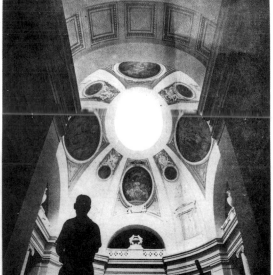

Closed on Mondays

A special day for planning
Perry T. Rathbone, museum director

**Photo story by Gordon N. Converse
chief photographer**

More than 500,000 visitors yearly pass through the huge bronze and wooden doors of the Boston Museum of Fine Arts, currently celebrating the 100th anniversary of its founding. But on Mondays the doors are closed to the public. From all appearances it is quiet within, yet it is one of the busiest days of the week. New exhibits are uncrated. The 4½ acres of floor space are washed or polished. The 178 galleries are dusted, cleaned, or painted. Light bulbs are replaced, plants watered and fed.

Acres of swabbing starts in the rotunda

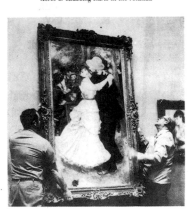

A Renoir is hung

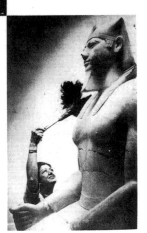

Dusting King Mycerinus

Left Page

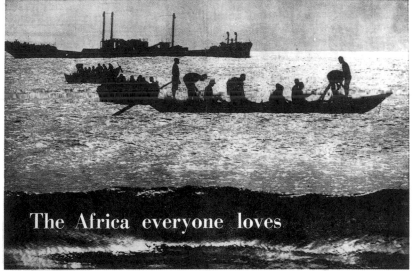

The Africa everyone loves

Ghanaian dawn

After a night of fishing and sailing, three fishing boats and a freighter prepare to land on the Ghanaian coast. Africa is a continent where the sea, the rivers, the deserts, and the jungles make dawns and sunsets particularly memorable.

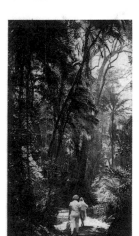

Zambian rain forest

Green horizons up and down and made greener by the mists of Victoria Falls. These jungle trails, hot, steamy, and filtered with the sounds of exotic birds, thrill African and visitor.

Cape Town

FROM SIGNAL HILL AFTER SUNSET, CAPE Town is a sprinkling of jewels on a velvet cloth of night.

Twenty-five miles from Nairobi, Kenya, on the Nakuru road the world suddenly drops away to expose the staggering Rift Valley with ragged mountains purpling the distance.

Over the edge of Victoria Falls between Rhodesia and Zambia ceaselessly pour tons of shimmering beauty sending back weaving pylons of mist.

Primitive Africa still exists in game parks and some undeveloped areas where the rhinoceros, elephant, kudu, and duiker live out their defiance of the 20th century and extinction.

Mud and thatch rondavels, home to most Africans, cluster like mushrooms on the hills and velds of the continent surrounded by little patches of "mealies" (corn).

But Africa is much more than the sum total of its scenery.

To white and black alike it is the land of opportunity. Black Africans are coming more and more into their own, although the tide of nationalism appears to have been stopped temporarily at least at Rhodesia's border.

In some 30 countries Africans are governing themselves, moving ahead in their own societies and finding their natural identities. This is not an easy task as current events imply, but it is nevertheless an exciting turn in history.

For whites, much of Africa is still a pioneering land. In newly free countries there is a vast deficit of skills. The white man will be needed for a long time to come to help forge new societies.

The age of industrialization is just beginning. Labor is abundant and cheap. Vast mineral resources remain to be discovered and dug. Small infinities of space can be fenced for ranching or planting. Some Southern African farms are measured in hundreds of thousands of acres.

And with this goes in many places a manorial way of life with several servants that disappeared in the Western world 50 years ago.

Even humble white families in Rhodesia, for example, can afford one servant (costs from $14 to $28 a month).

In the posher suburbs of Nairobi, Lusaka, Salisbury, or Johannesburg many homes have several acres of land, a tennis court or swimming pool, or both. With the help of a "garden boy" or two, and a flair for flowers, gardens flaunt color all year round.

In Zambia, a white man can work in copper mines for several years, salt away his money, and then return home to England or South Africa and set up a small business. In the meantime, he and his family live in a neat suburban town—suburban, however, only to the mine itself and endless miles of African bush—with a high standard of living.

If one adds to all these attractions a generally mild and sunny climate in much of East, Central, and Southern Africa one can see why so many people make Africa their home.

The good life explains in large part why Rhodesians and South Africans are determined not to hand their country over to African rule in the near future. They feel their way of life would be destroyed.

Yet many whites still living in Kenya have made the adjustment to black rule without major change in their living standards.

Frequently, Europeans who leave Africa return. They find that its natural beauties, challenges, comforts, and climate are irresistible. This bears out the old saw that "you can get yourself out of Africa but you can't get Africa out of yourself."

This is the final page of 12 pages on Africa today.

Africa today

Story by
Robert M. Hallett
Staff correspondent of The Christian Science Monitor

Photos by
Gordon N. Converse
Chief photographer of The Christian Science Monitor

Animals evoke Africa

Nothing conveys the feel of Africa to a non-African more than its animal life. Rhinos, elephants, hippos, various deer, giraffes, and zebras are still what most come to mind with the word Africa.

Right Page

Cobbled Street Glistens in Winter Sun

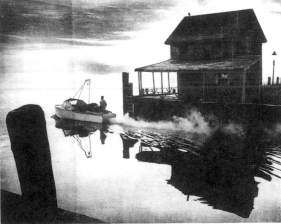

Nantucket In Winter

Photos by Gordon N. Converse, Chief Photographer

Nantucket, once called "the far-away island" by Massachusetts Indians, lies 30 miles due south of Cape Cod. A leading whaling port of years past, the island now boasts one of the finest examples of an unchanged early American town.

Nantucket comes alive during the summer months.

Off-islanders boost its population to more than five times its normal size. The rest of the year its remaining 3,500 islanders dream of the past and ready themselves for the season ahead. The island's quiet cobblestone streets and winding lanes take on a new look when revisited "off-season."

Scallop Boat Passes Through Early-Morning Fog

Old Windmill Takes a Winter Rest

Sankaty Light

Three Identical Georgian Bricks Are Pride of Main Street

Sliding Near Island Moors

Largest Little Weekly Brings All the News From Far and Near

'Around the World In Pictures'

By Gordon N. Converse
Chief Photographer of The Christian Science Monitor

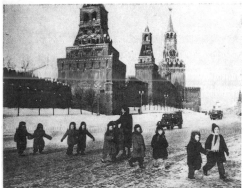

Children, Shepherded by a Teacher, Cross Moscow's Red Square Beneath the Kremlin's Towers

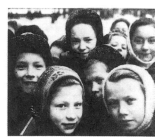

American Cameraman Fascinates Russian Youngsters

With this page The Christian Science Monitor begins a series designed to give a clearer understanding of the peoples among whom we live. All photographs in this series, which will run every Friday, were taken by this newspaper's chief photographer on his recent round-the-world trip.

Fun in Moscow's Bitter Winter

Tasseled Orange Lampshades Symbolize Soviet Social Standing

Thirst for Knowledge Knows No Boundaries

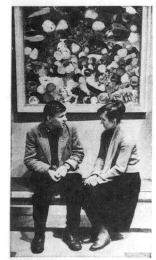

Boy and Girl Meet in a Soviet Art Museum

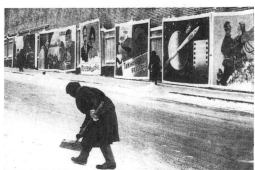

Soviet Contrasts: A Solar Satellite and Female Drudgery

At a Country Auction

'Did I Hear Five Dollars?'

New Englanders—and their city cousins from all over the country—are drawn to an old-fashioned country auction. Here's their opportunity to garner "previous" antiques from attics, barns, and cellars. Rare books, an old spinning wheel, a [...] with glass, even a fairly respectable parasol of the type Grandma used to carry.

All are grist for the strident tones of the auctioneer.

All Pictures by Gordon N. Converse, Chief Photographer

'A Handy Purchase'

Homeward Bound

'Oh, Boy!'

'How Much?'

White Elephants

'A Genuine Boston Rocker!'

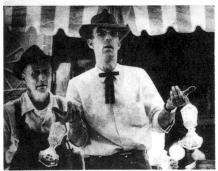

'Who'll Make an Offer?'

End of a Perfect Day

Photojournalists have a powerful tool in their hands. With the camera they can say what they wish and paint any situation good or bad, beautiful or ugly.

■ A photograph can honestly describe a situation without words or even faces. There is a great deal of tension in this scene. These men were Arabs trying to get back into Jordan from Israel during the war in 1967. The bridge had been bombed-out, and a temporary one just constructed. They had just passed through a security checkpoint, and were making a final dash for their homeland.

Allenby Bridge
at the border of
Israel and Jordan.

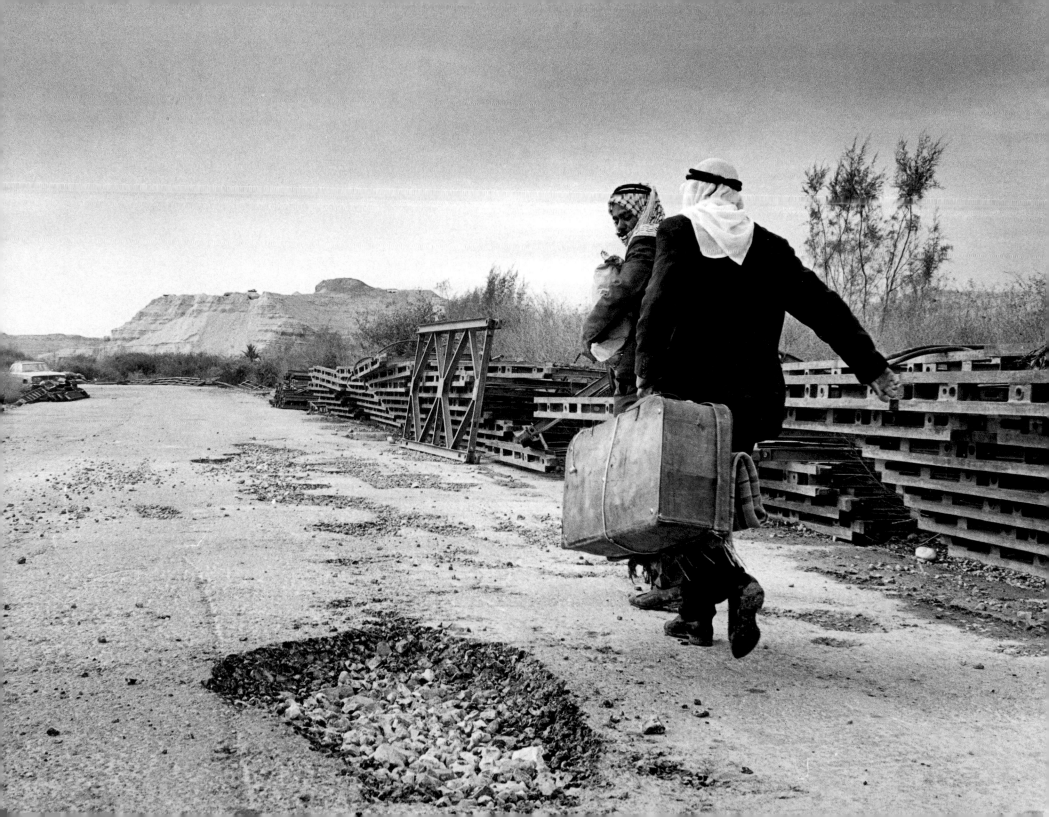

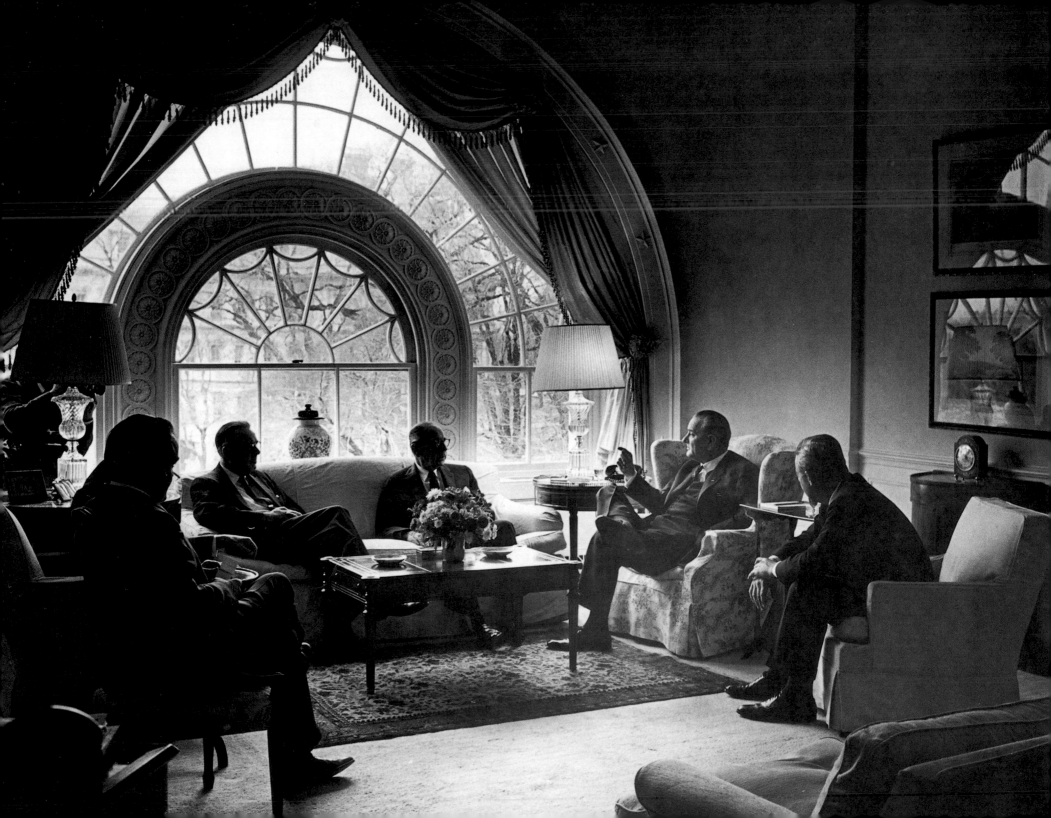

New York, New York, USA

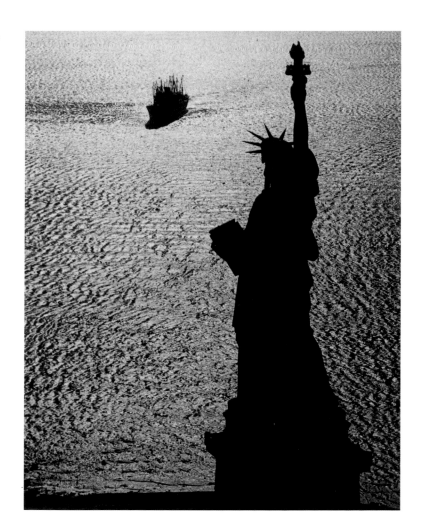

■ Three days after Lyndon Johnson suddenly found himself President of the United States, the Monitor sent me to Washington. There were 20 photographers in the White House press office, all waiting to take pictures. But I made connections with a White House Staff member, and he arranged things so that I could get into the President's office and spend the entire day with him, meals and all.

Here, the President was talking with senior officials. The picture is a good example of "forcing" natural light; most of the light was coming from the window, and in the darkroom I had to intensify, or force it, it by burning it in.

Washington, D.C., USA

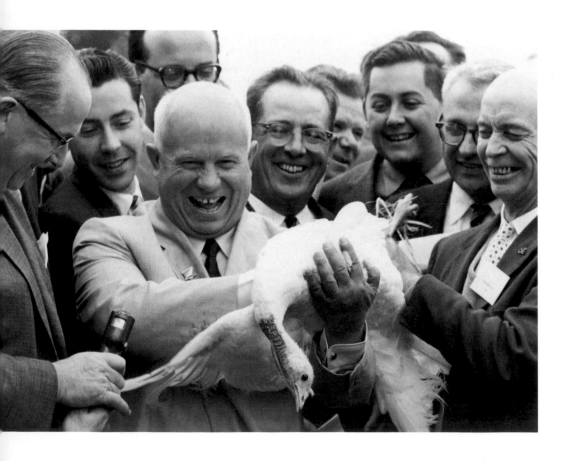

■ Nikita Khrushchev was visiting a turkey farm in Maryland during his visit to the United States. This scene must have taken him back to the days of his youth when he lived on a farm—he seemed very familiar with the birds. The unexpectedly jovial picture, which contrasted strikingly with the protests going on at the same time [see facing page], was picked up and used by many of the wire services throughout the country.

Two days later, Khrushchev was banging his shoe on the table at the United Nations.

Beltsville, Maryland, USA

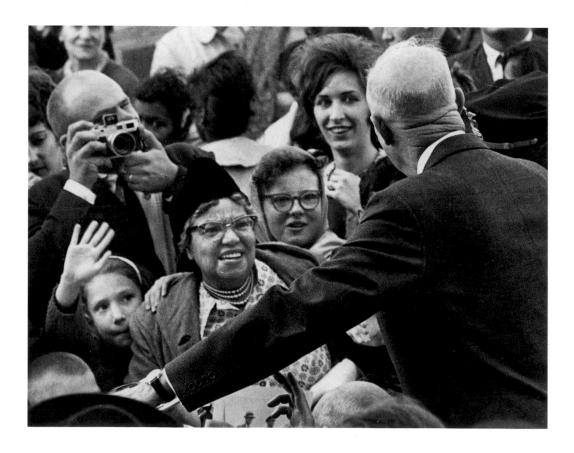

■ Sometimes I would be be assigned to go to Washington for the day to take photographs, with a schedule of appointments following one after another. And it wasn't unusual to be told that a person had very little time for me or to find a person difficult to work with.

I found I could ask a secretary or co-worker ahead of time what my subject was all about. I'd try to find out what qualities about the man or woman were good or not good; what their interests or hobbies were. I could ask any number of questions that all helped give me an idea of who the person was, and that in turn would help me to talk with them, work with them, and obtain the photographs I needed.

Washington, D.C., USA

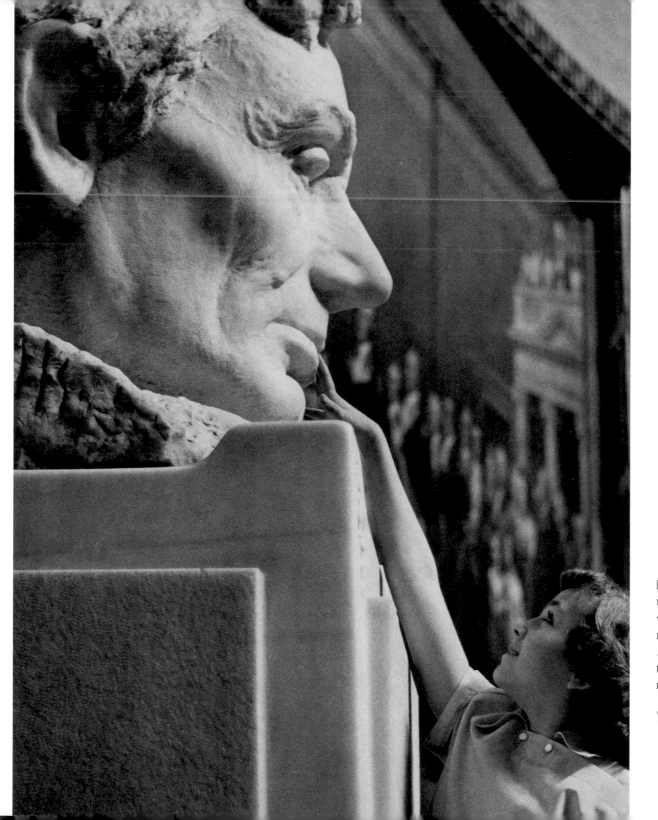

■ As schoolchildren passed through the Capitol Rotunda one morning with their classmates and teachers, I noticed this young girl holding back . . . just long enough to rush up and touch the lips of someone she recognized so well.

Washington, D.C., USA

I could never type words. But with a camera in my hand, I could communicate.

South Africa

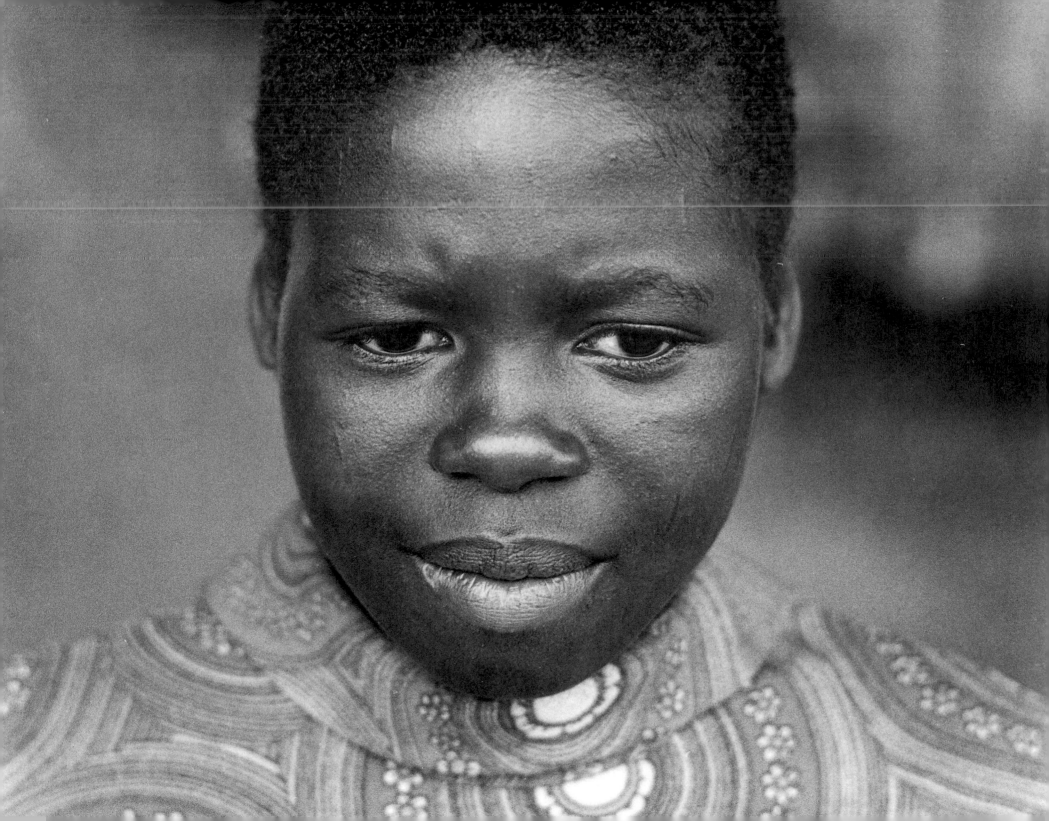

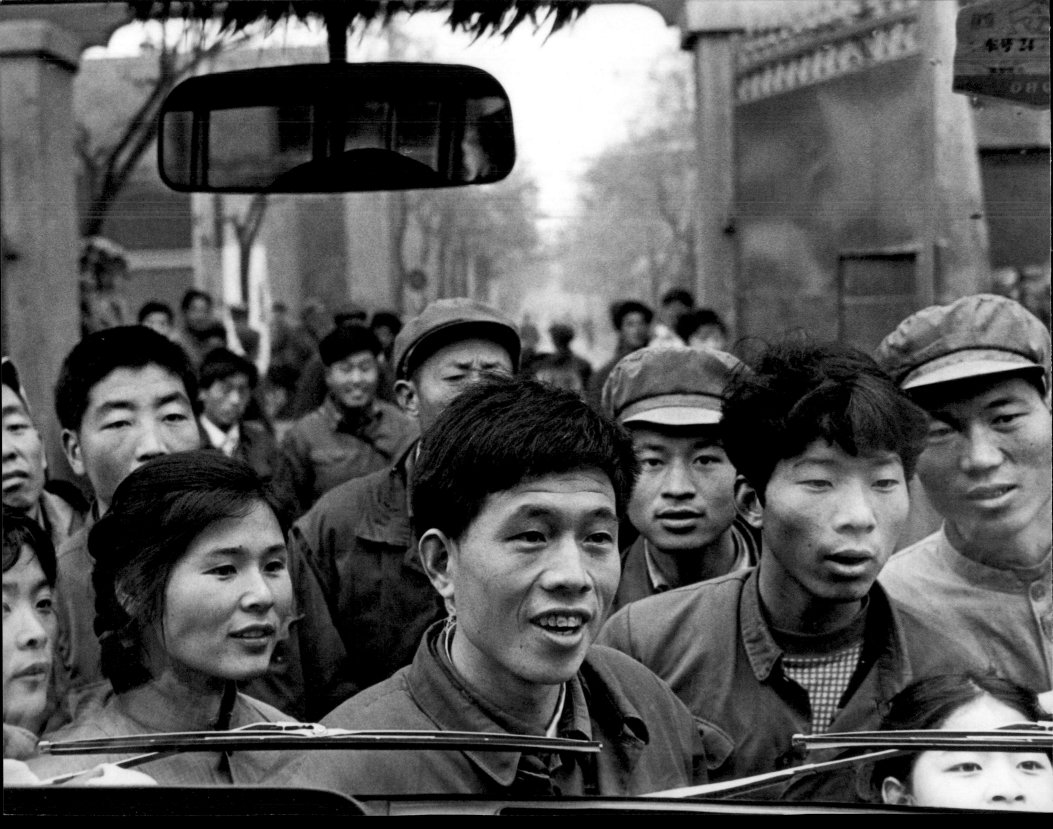

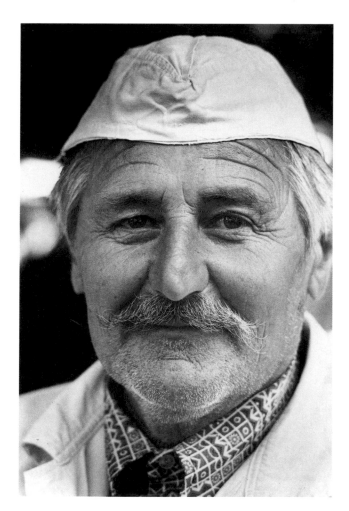

Belgrade, Yugoslavia

With my work, I sometimes wanted to disturb our readers enough so that they would understand an ugly world situation and begin to respond. But I didn't want them to react by turning away and refusing to see a scene, as though it never happened. I was trying to say, "It is happening. Children are hungry." If you get into the hearts of other people, then they will be concerned enough to do something about it.

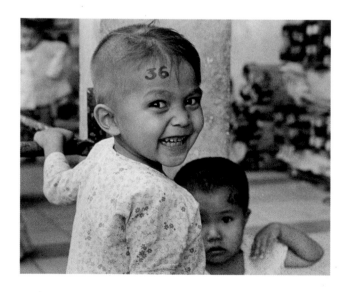

■ In 1973 I was sent to Vietnam for one week to photograph the war.

But after I had taken all the pictures of the war that I needed to, I heard about a refugee camp in Saigon [Ho Chi Minh City] that was so loaded that they couldn't even give names to the children. Instead, they just painted numbers on their foreheads to link them to their native villages.

The children were coming in by the truckload. Many were orphaned; their parents had either been killed or were missing. They were terribly hungry, and some were badly hurt. It was a very touching, very desperate situation. And yet seldom did I ever hear any of these children cry. They were the quietest and the best be-haved children I had ever seen. They just wanted comfort and a little love. Many times in the middle of my photography I would take time just to smile or give them a hug.

Although I was a newspaper photographer, and my first reason for being there was to take photographs, there were moments during these trips when I would stop my work and just help a person hang on—stay alive—for a few more minutes. It was that desperate. And nothing was worthy of a good picture of a bad situation if I couldn't respond to another human being's need for help.

Saigon, Vietnam

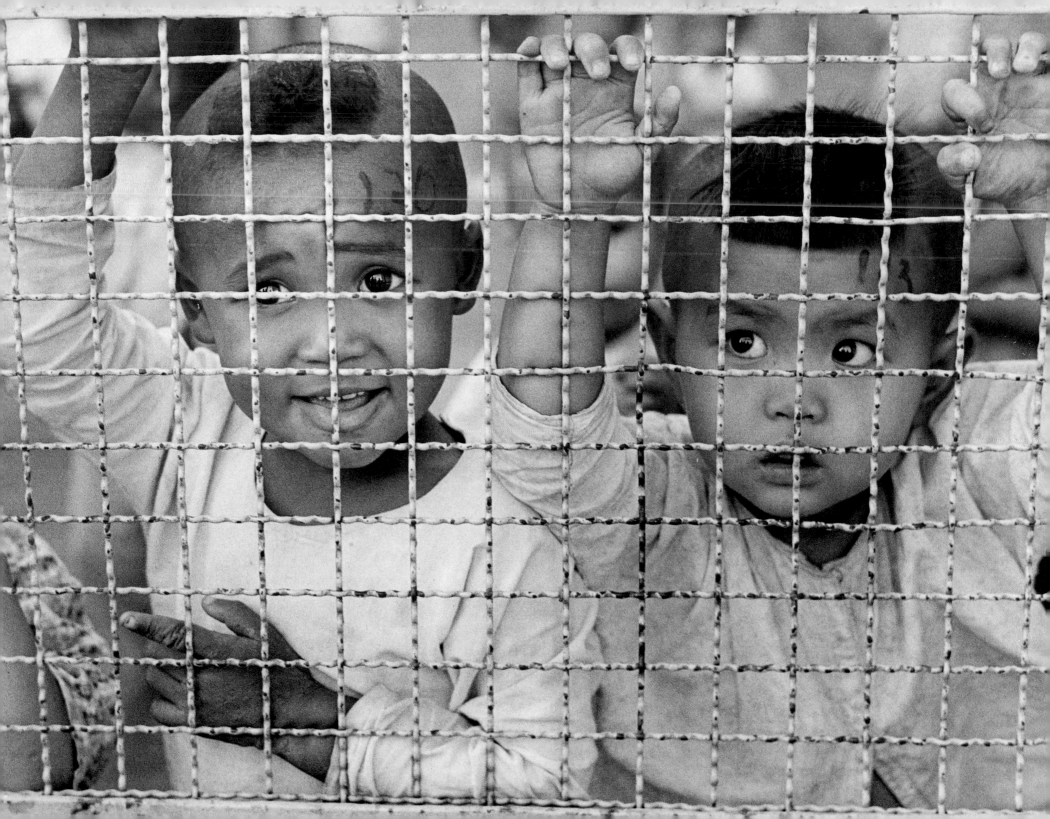

If I have succeeded as a photographer, it's because I have gone to the work with an open heart.

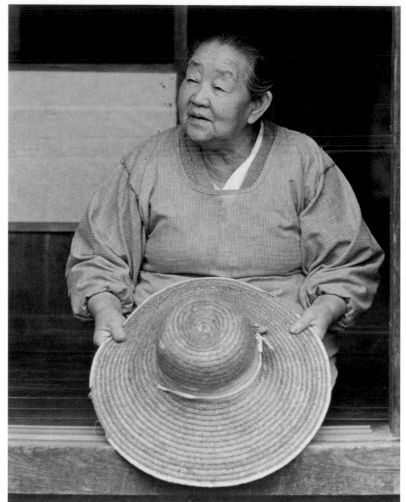

Kazuno, Japan

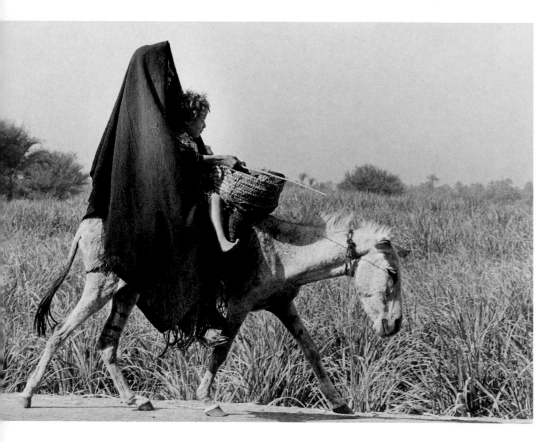

Egypt

Java, Indonesia

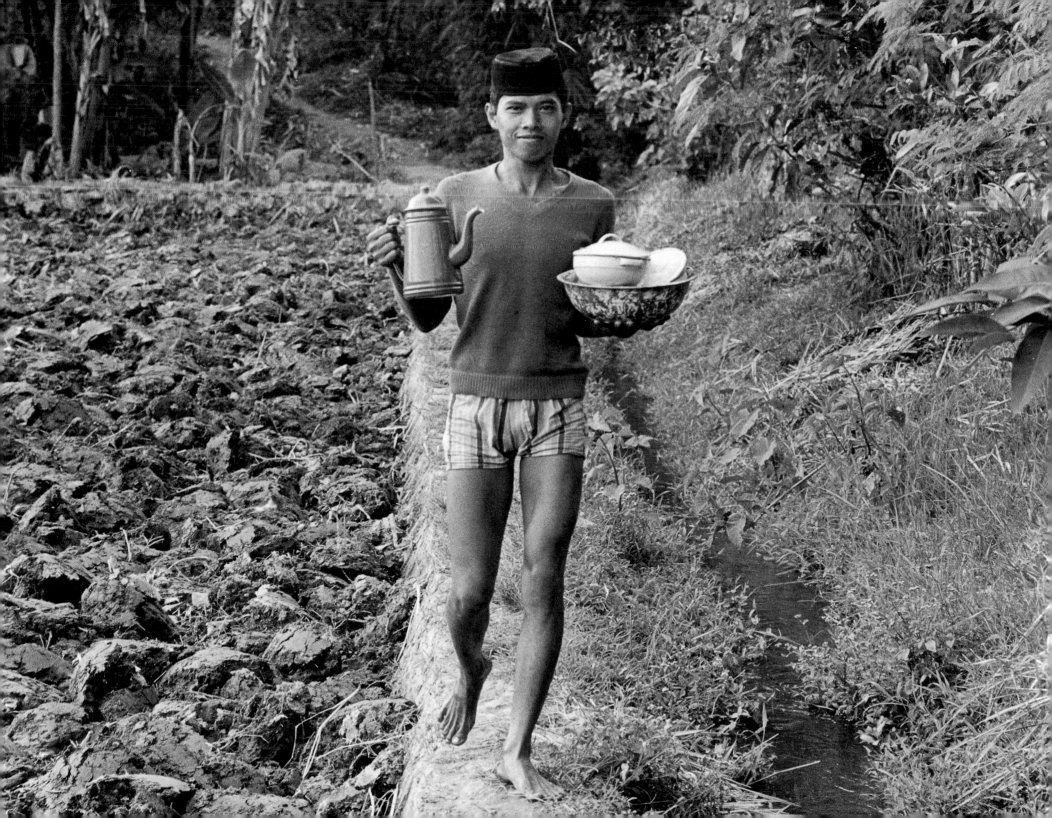

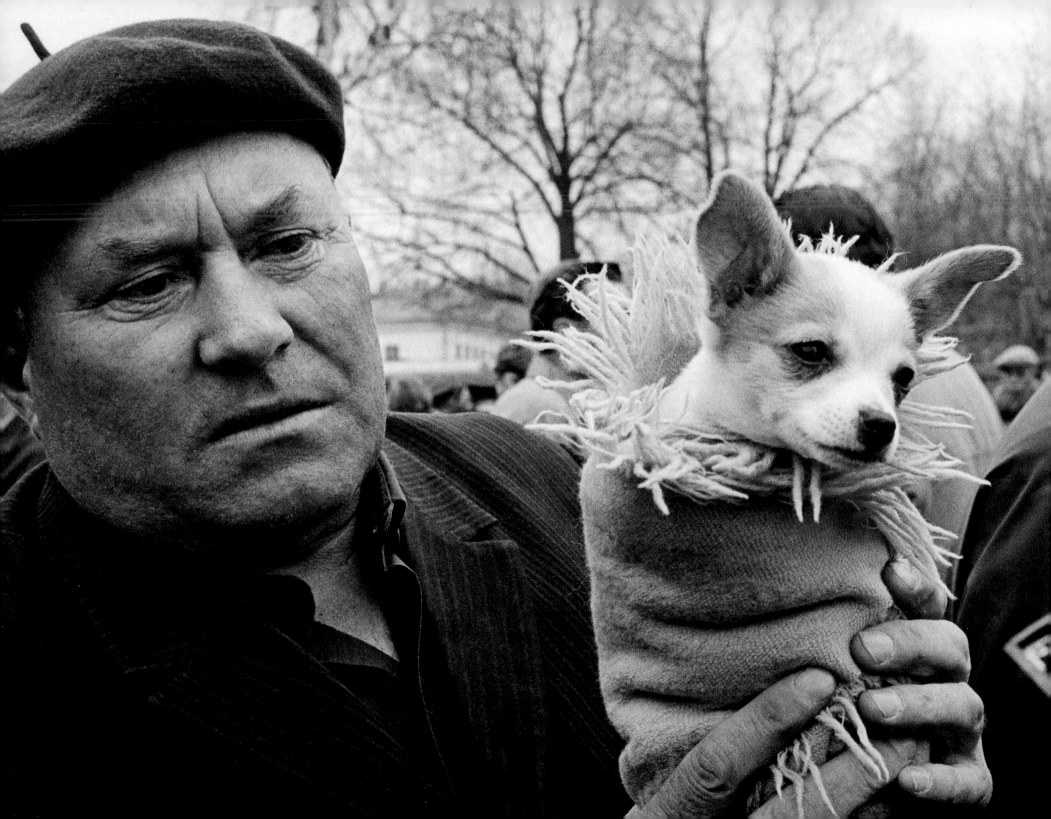

I would first try to discover the best of what a country had to offer, and then to bring dignity to the people I photographed.

Bali, Indonesia

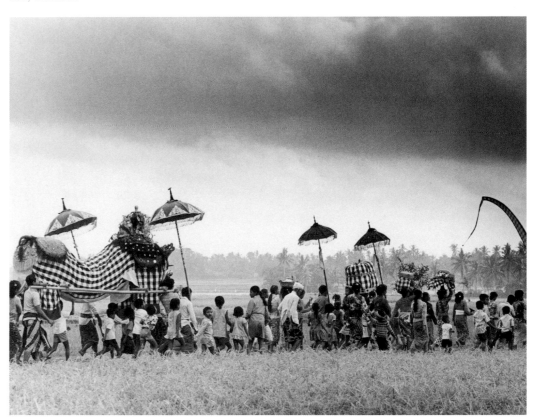

■ This scene came from an open-air market in Moscow devoted exclusively to selling pets. On Sunday mornings, people would come with all sorts of pets in hand . . . cats, dogs, turtles, goldfish, and all kinds of birds.

Moscow, USSR

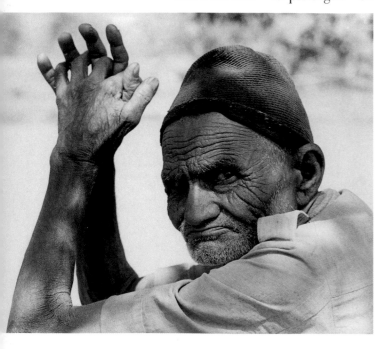

■ "If you think Katmandu is remote then you should try to get to Pokhara before you leave Nepal," said the American Ambassador. "There's a plane flying up there tomorrow. If you can get aboard you'll see one of the few places left on earth completely untouched by modern civilization."

The early morning flight was a once-a-week affair made in a small and very old twin-engine plane. It had a full load—19 passengers—all Nepalese or Tibetan refugees returning to their hamlets from Katmandu. After the passengers were seated, on came a huge load of fresh vegetables and meat, all packed high in the aisle and not strapped down. Before the rear door was slammed shut, three goats were pushed in to complete our cargo. It took all the power the little plane could muster to get off the ground.

After a roller coaster flight high into the Himalayas we swooped down for a landing. Everything from sheep and wild monkeys to extremely large birds were demanding their rights to the field we were about to land on. We had to circle a number of times.

When my feet touched solid ground once again, I suddenly felt farther from home than ever before. Just as the Ambassador had said, it was a very different world indeed.

The village had one dusty road. There were no cars; just animals and people. They looked at me and I looked at them. They examined me from head to foot. They were fascinated by my clothing. Whole families were filtering into town from the hills. Many had walked for days, bringing small bundles of wood to sell. Some, I am sure, had never seen a non-Nepalese before.

By noon I had wandered high above the town, capturing everything I saw on film. A magnificent lake lay before me. Snowcapped mountains reflected on all sides. Only one figure was present, an old man squatting beside his hollowed-out wooden canoe.

I was getting hungry, but hadn't seen any edible food along the way. I remembered a small jar of Heinz pickles tucked in my bag, a gift from an embassy official. As I crunched away on the contents the old man stared. His eyes were penetrating, especially through my viewfinder as I took his picture. Wondering if he wanted me to share, I handed him a pickle. He smelt it, touched his tongue to it, and carefully tucked it into his shirt pocket. Then he continued to stare.

Suddenly it came to me that just the week before in the markets of Old Delhi, Indians had been selling old bottles, jars, and rusty tin cans as treasured items. My hand reached out with the empty jar. His eyes lit up. Gently he took it and walked to the water's edge, washed it thoroughly and polished it well on his shirt tail. Then he washed the cover and gently attached it.

As the old man turned and headed down the slopes toward the village, he smiled. He was the proud owner of a brand new jar.

Pokhara, Nepal

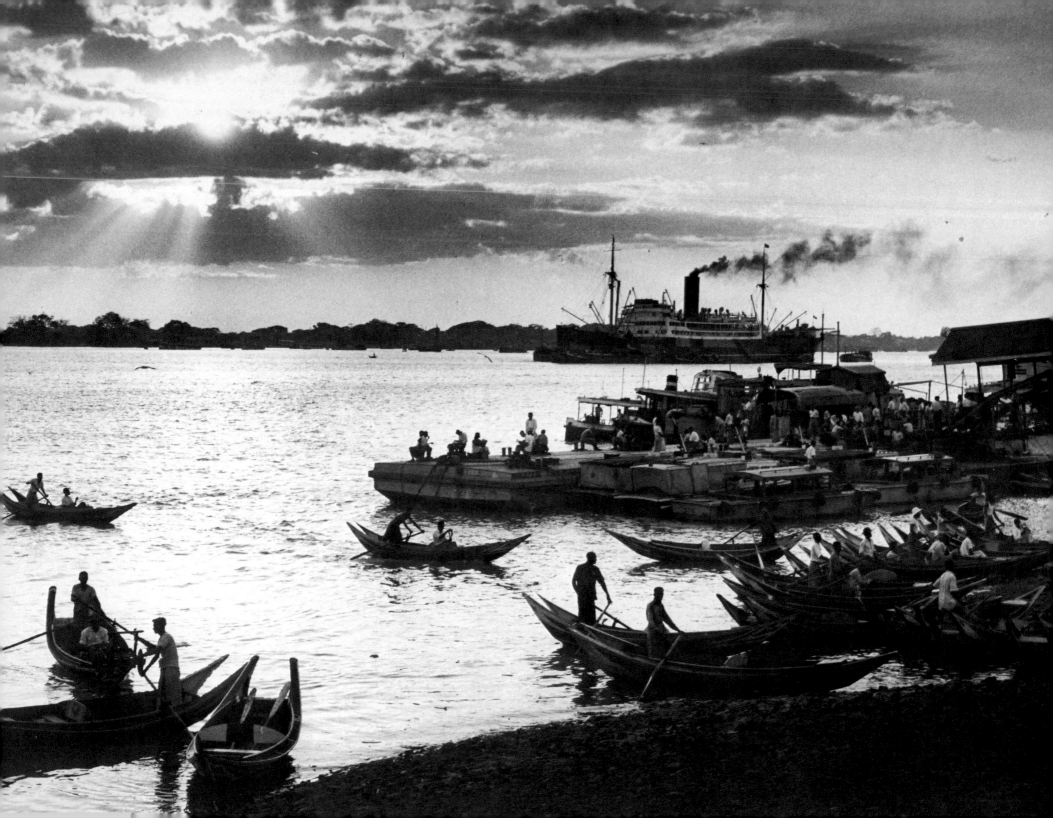

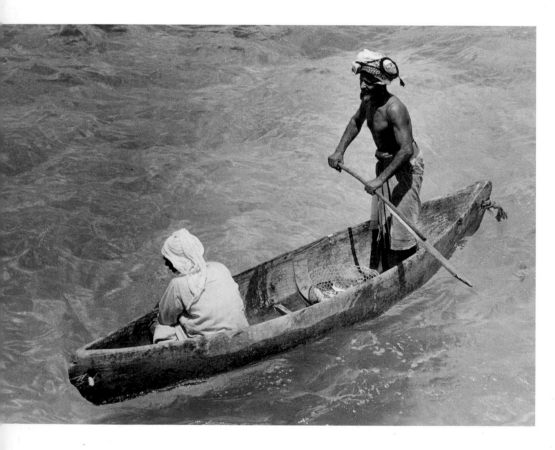

United Arab Emirates

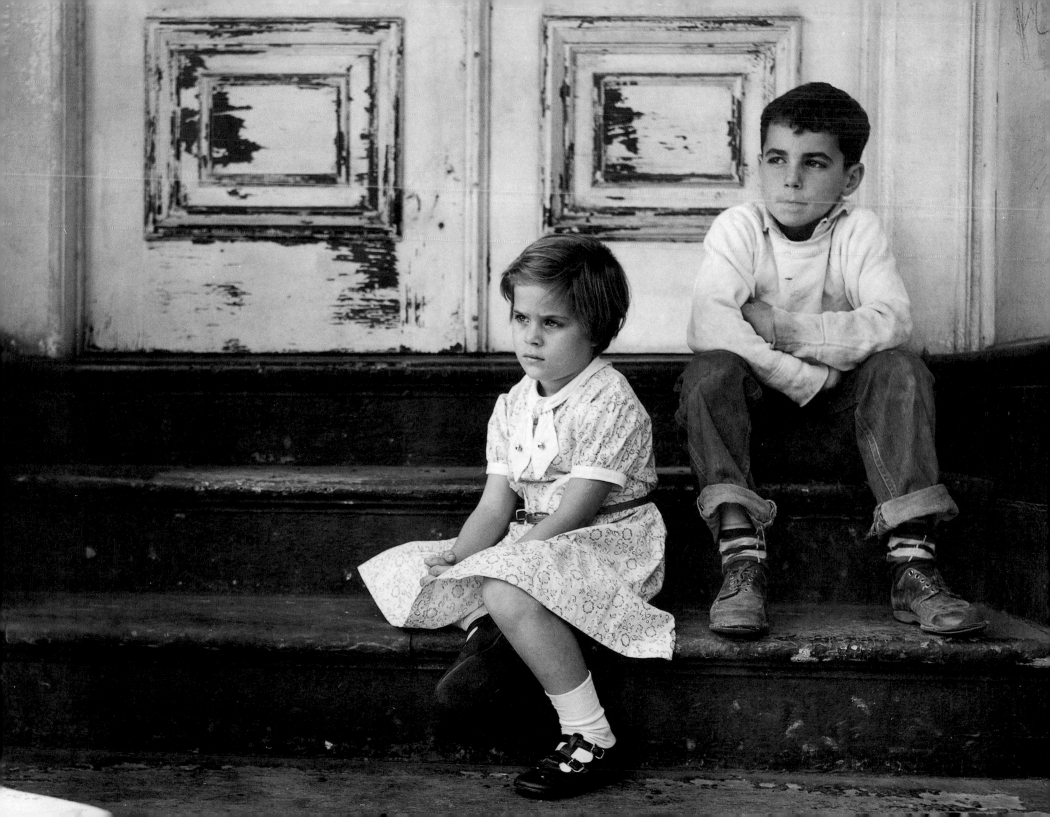

■ The first day of school had come, and the bells had rung. Old-timers in the second, third, and fourth grades hustled to their preassigned classrooms without difficulty.

Left were the first graders. Confused and bewildered, they could easily be spotted. All had new shoes and lunch boxes—some a missing tooth or two. The principal, secretaries, and teachers all conducted a vast roundup. Correct rooms and desks were then found; corridors emptied and doors closed. Quietness reigned. School had officially begun for another season.

The press had been taking the usual "first day of school" photographs and I soon considered my assignment complete. But as I left the building I suddenly caught a glimpse of a tiny figure peeping out from the edge of a tall brick wall.

The little boy was a first grader. He had ventured all the way from home because his mom was working the early shift and unable to come with him. He just stood, waiting for someone to help him.

Forgetting deadlines for the moment, I extended a helping hand. Together we investigated. His room was at the end of the long corridor. The teacher welcomed her missing pupil with a warm smile.

As I left I turned. He was settling into his seat behind a brand new desk, and he suddenly looked brave.

Boston, Massachusetts, USA

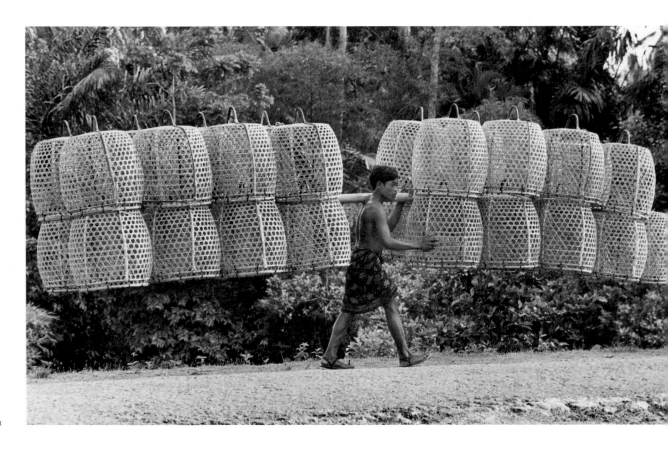

Bali, Indonesia

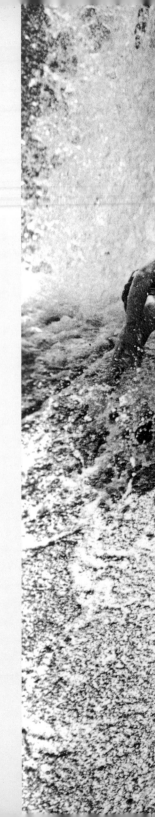

120 *I like to think of my camera as a diary. With it I record my daily experiences on film.*

Boston, Massachusetts, USA

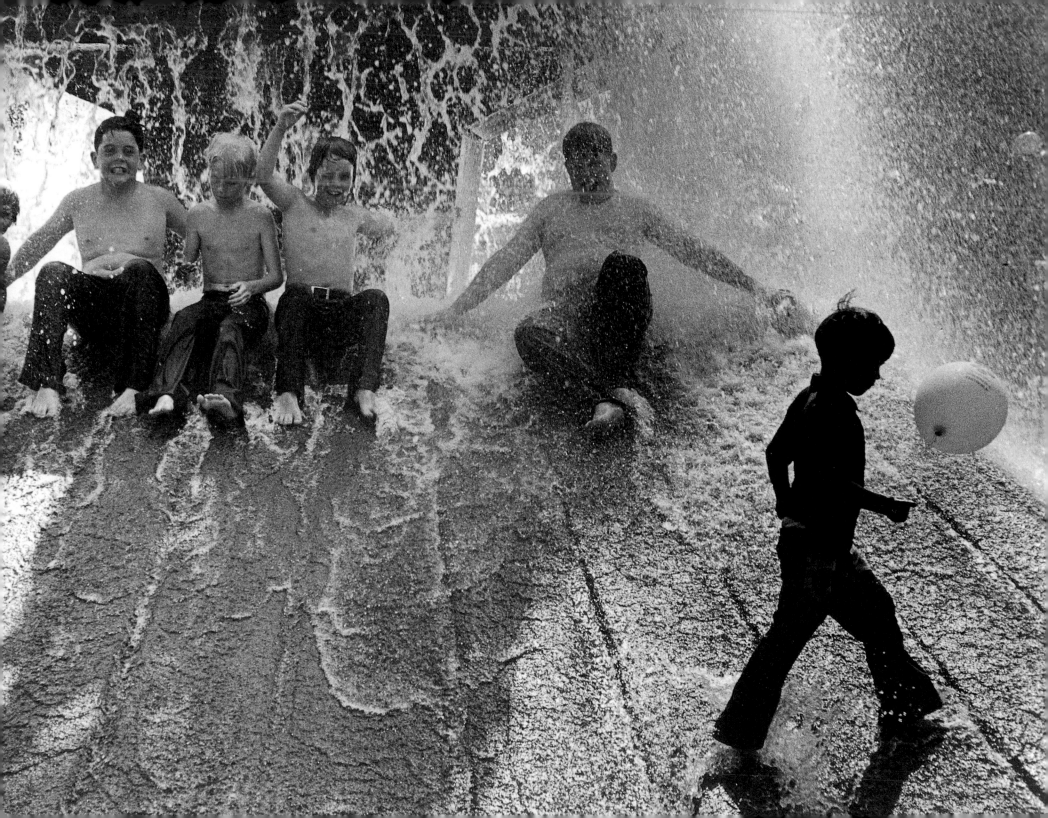

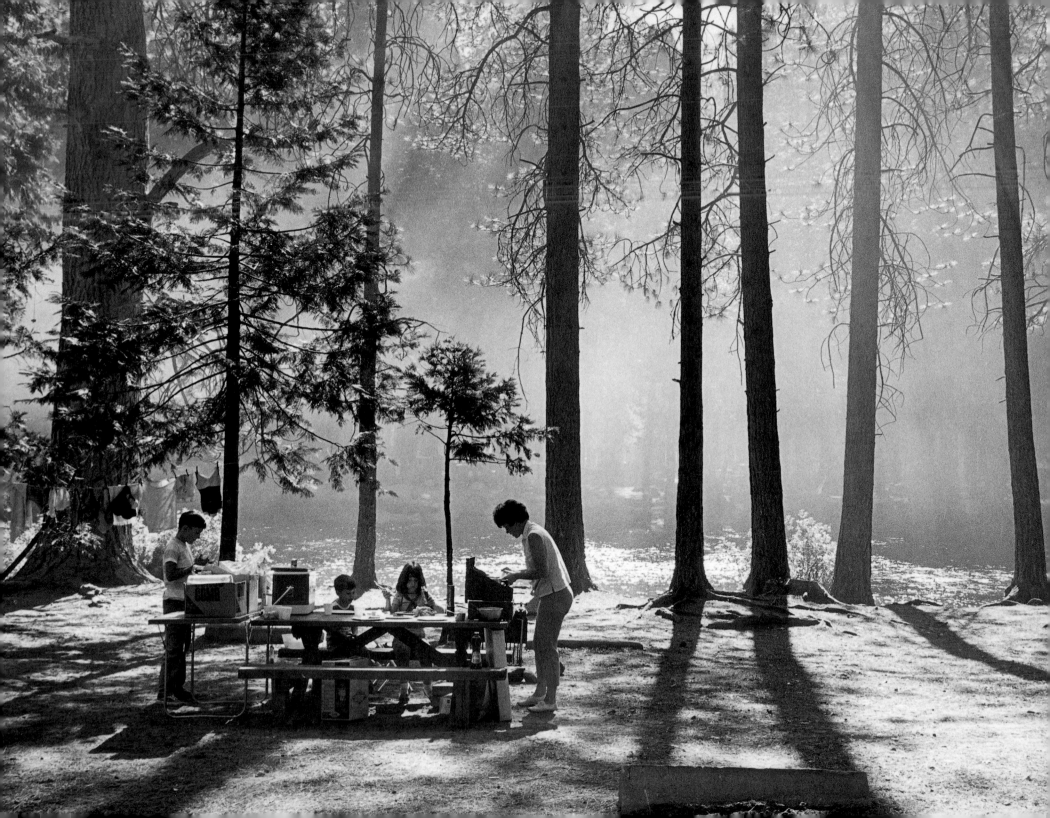

The photojournalist helps people see what they normally do not have the time to see or discover for themselves.

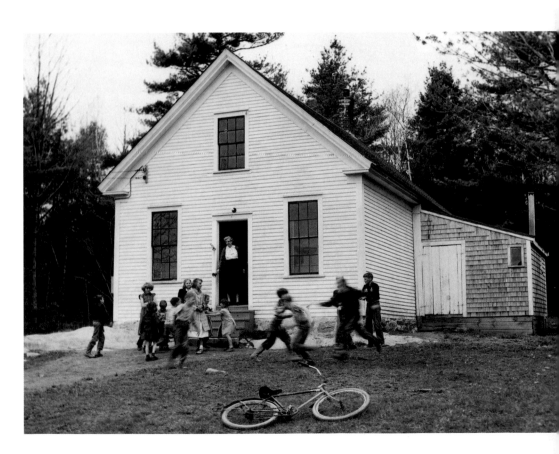

Maine, USA

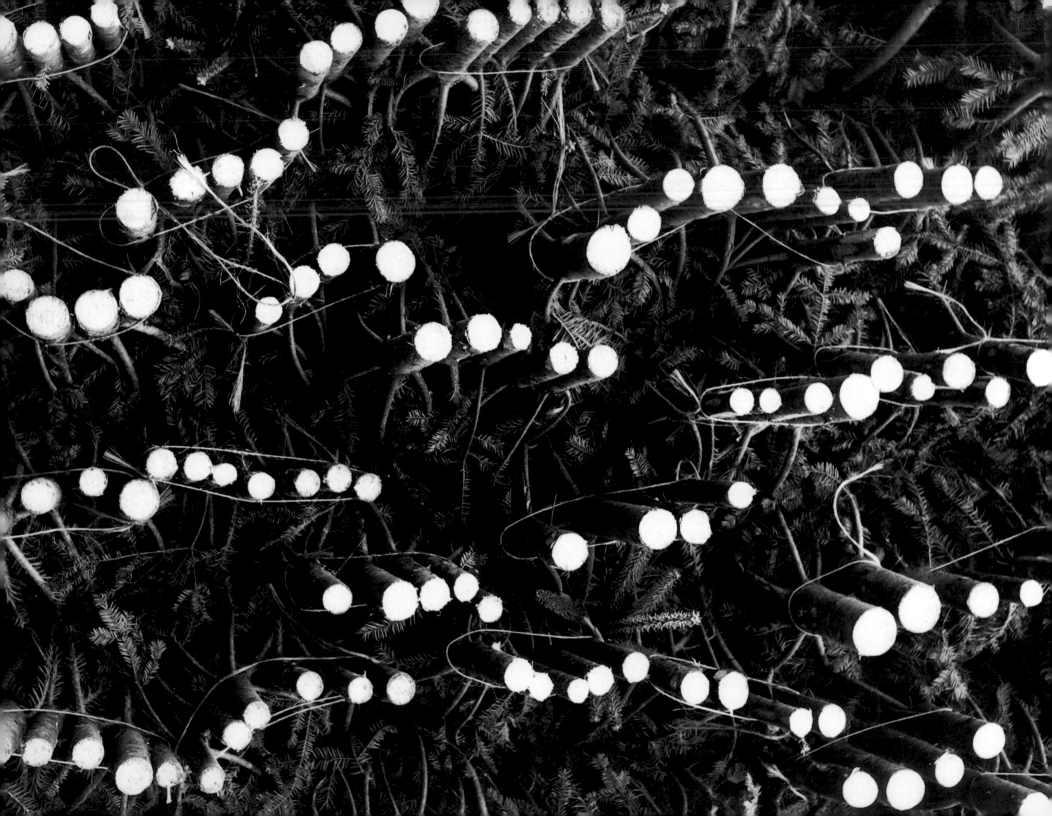

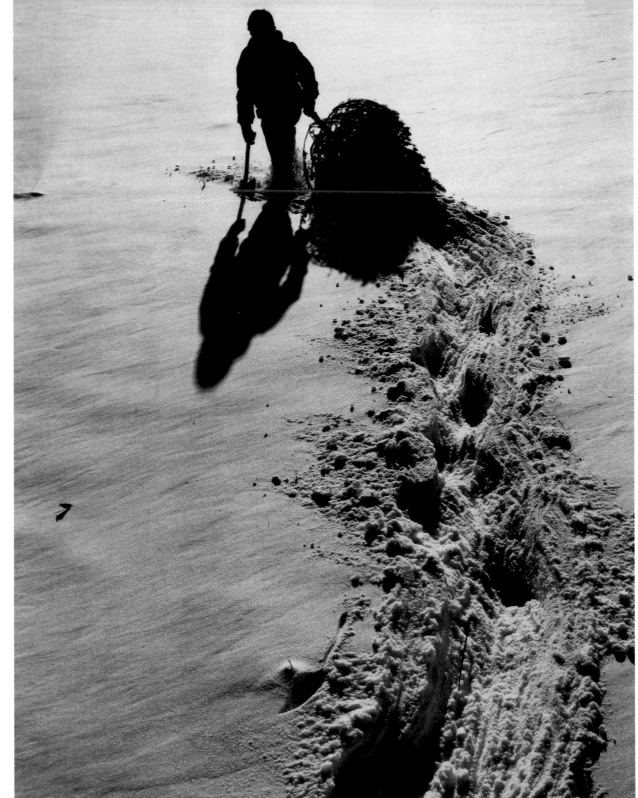

Needham, Massachusetts, USA

Boston, Massachusetts, USA

*Needless to say, the more exciting the day is, the
more dramatic the pictures will be.*

Water Buffalo Races, Indonesia

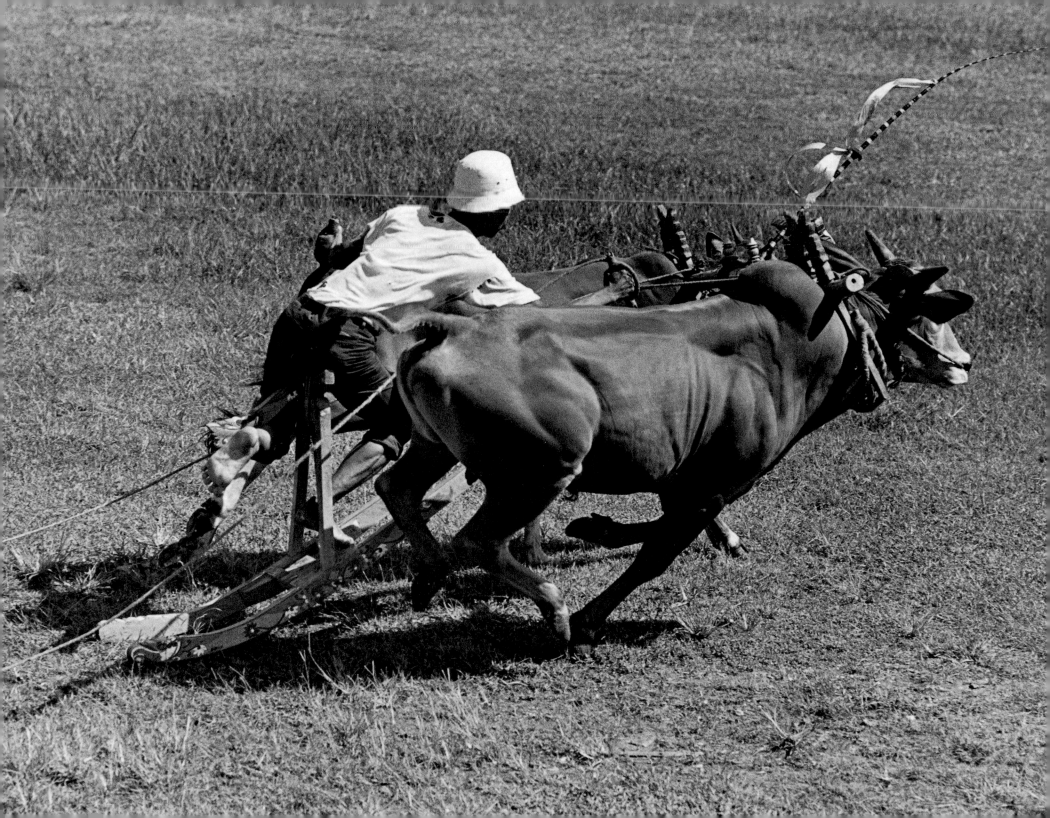

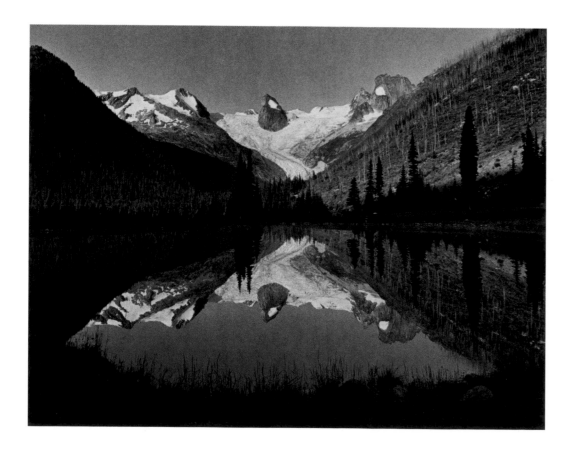

■ In 1983 I went "helihiking" in the Canadian Rockies. By this process, people of all ages can enjoy the excitement of being airlifted to mountain peaks and glaciers that would take days to reach on foot.

The helicopter seemed to evaporate into space within seconds after we got off, leaving us alone in an alpine world.

Some of us immediately headed for the peaks above. Others wandered down the slopes to the mountain meadows below. A few, maybe the wisest, remained close to where they had landed and just absorbed the most spectacular views they had ever seen.

The high point of the trip took place on our last evening. Darkness had settled in over the lodge and the valleys below, but we could still see the sun brightly lighting the highest peaks. It took only one of us to suggest that we take the helicopter aloft to watch the sunset. Once above the top of the ridge, we said nothing as nature silently played out its final act of the day. It was an experience that will forever be etched on my mind's eye.

British Columbia, Canada

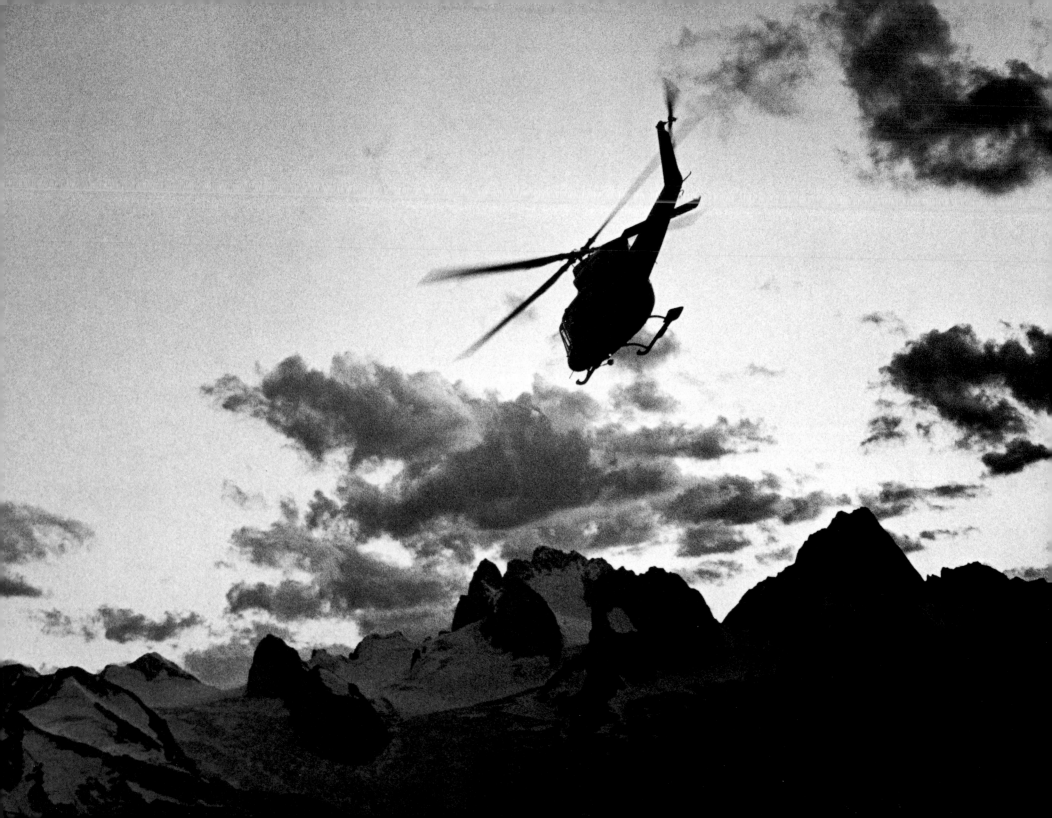

*I would often find that my plans suddenly changed
and took me to an unexpected city.*

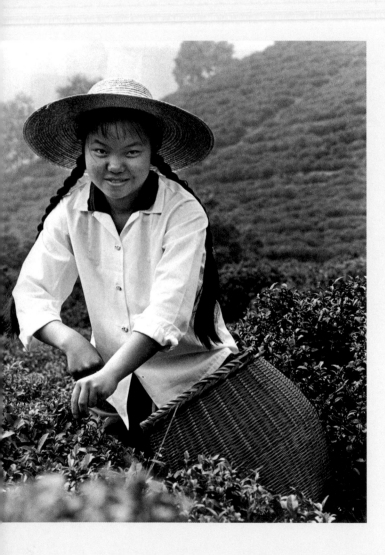

China

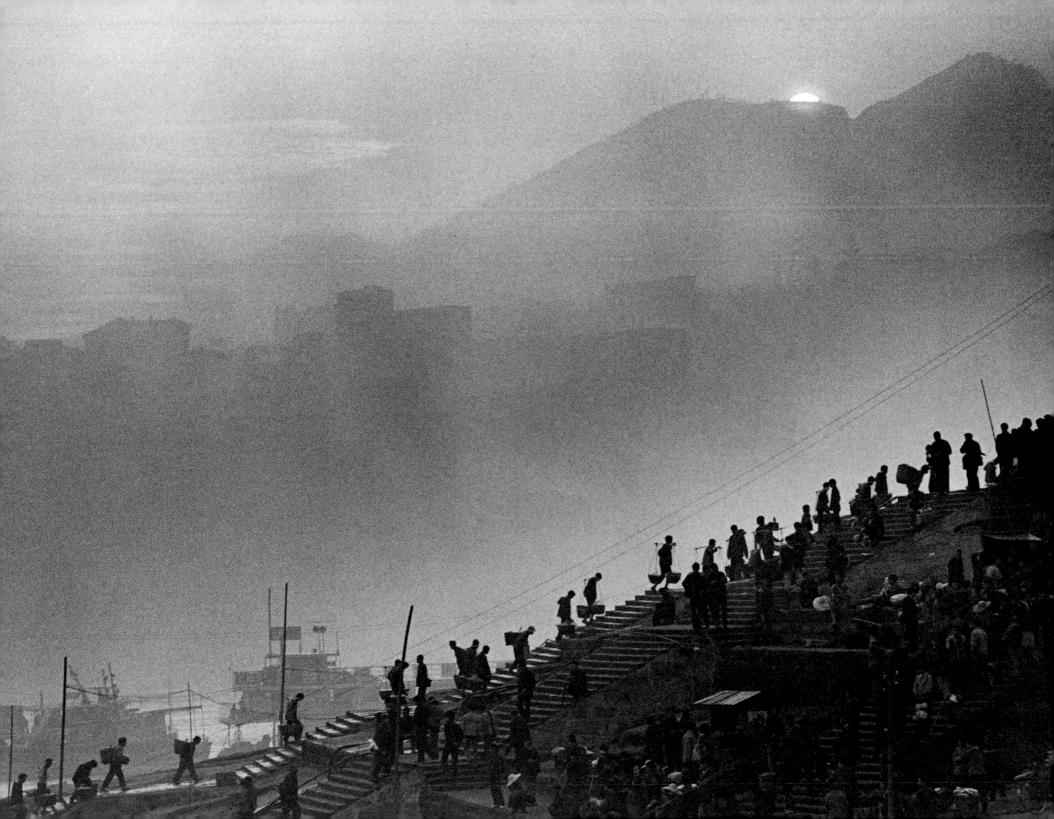

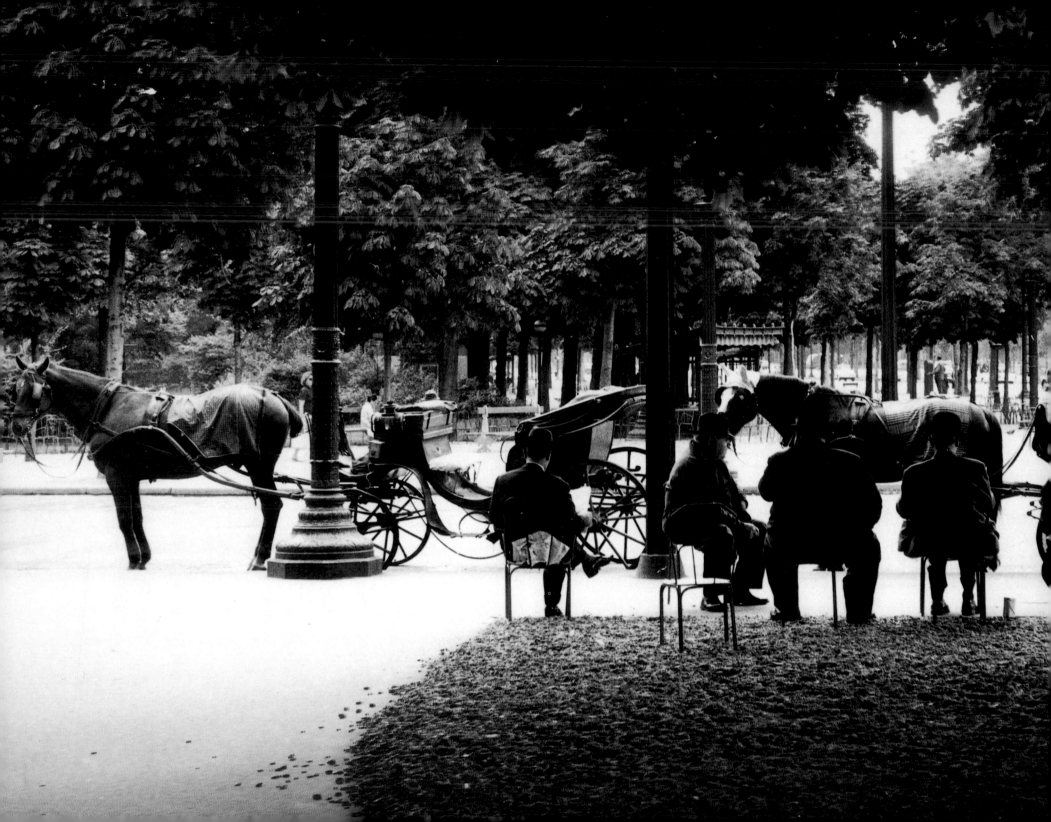

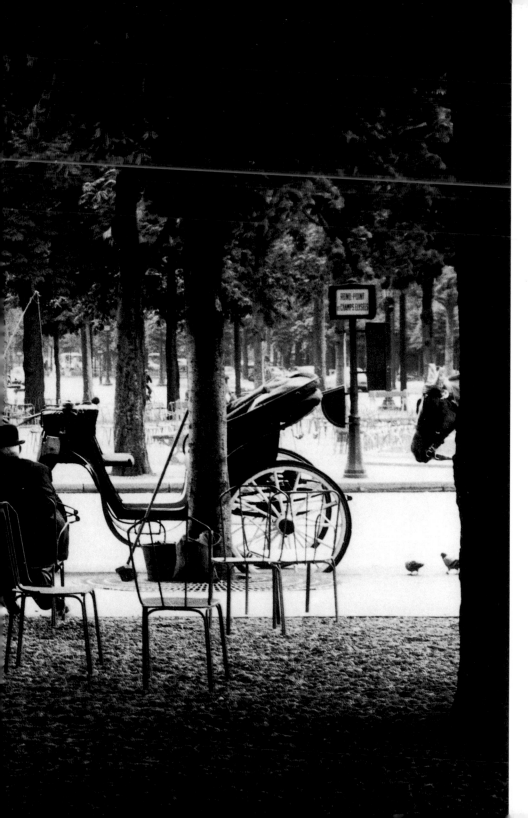

I found walking to be the only way to get the feel of a city, investigating streets, markets, parks, shopping centers, and alleys. These walks often produced some of my best material: photographs of people in their daily lives.

■ To get the most out of my usually short stays, I would first go to the newsstand in the lobby of my hotel and look at all the postcards. (As stiff and stilted as most of them are, they usually give a good idea of the important places in town.) I would purchase a city map and place a cross at the location of my hotel so I would not get lost.

Then I'd walk and walk and walk, often leaving my hotel long before most guests were up and returning long after dark.

Paris, France

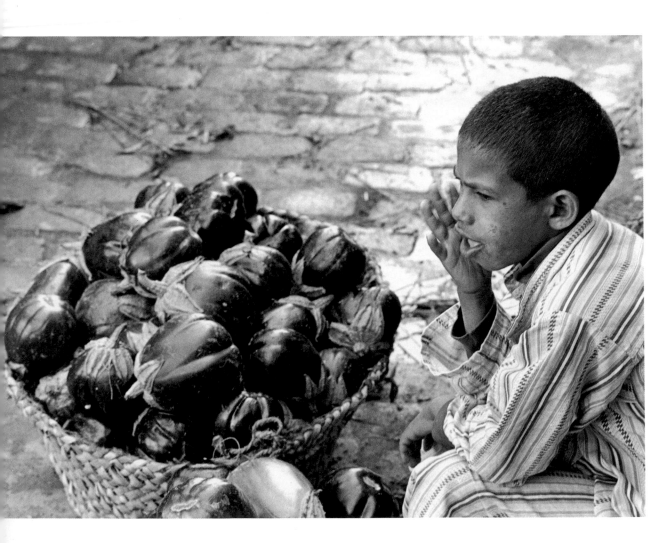

Cairo, Egypt

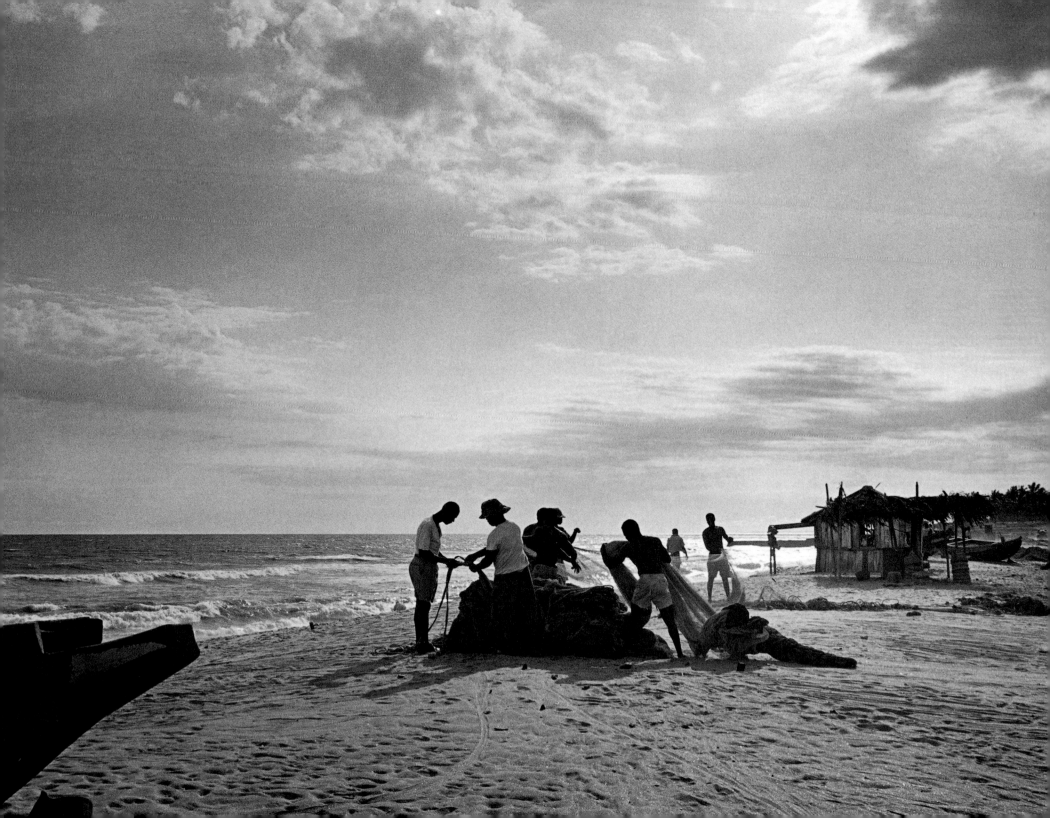

■ Salipa Bishare Musich, an Arab teenager, seemed quite surprised to find a stranger in his backyard. He had come to check on the family sheep.

"If it's Bethlehem you are looking for," he said, "it's up on the hill."

I thanked him but quickly informed him I had seen it all days before. With thousands of others I had arrived in what seemed to be an endless procession of tourist buses and gleaming limousines. We had been herded into the traditional birthplace of Jesus. It was in a cellarlike grotto below the ancient Church of the Nativity in Manger Square. We had then been given a ten-minute stop at one of the many souvenir shops filling the marketplace before returning to Jerusalem, only five miles away.

From then on I decided I would travel alone. With the Bible as my guide, I would search the Holy Land for what might be left of the land Jesus knew and loved so much.

On the fields before me, nearly 2,000 years before, shepherds were "keeping watch over their flock by night."

Bethlehem, Israel

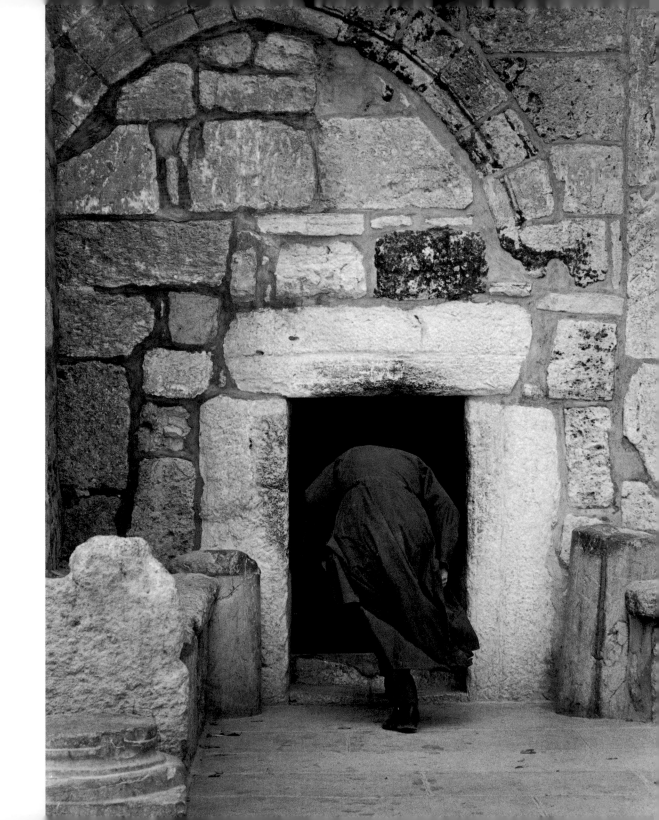

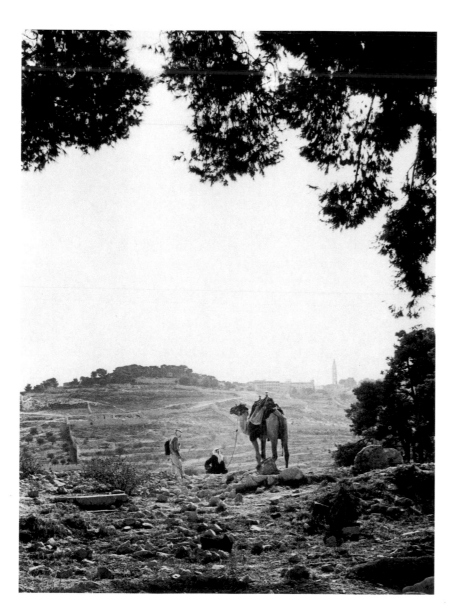

Israel

Sturbridge.
Massachusetts. USA

Nantucket,
Massachusetts, USA

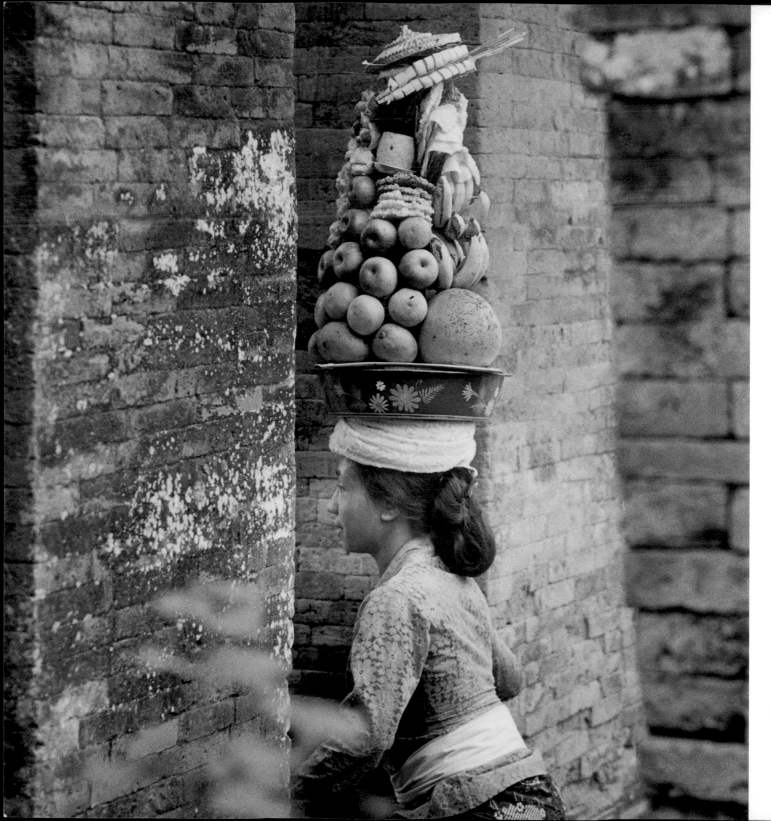

Java, Indonesia

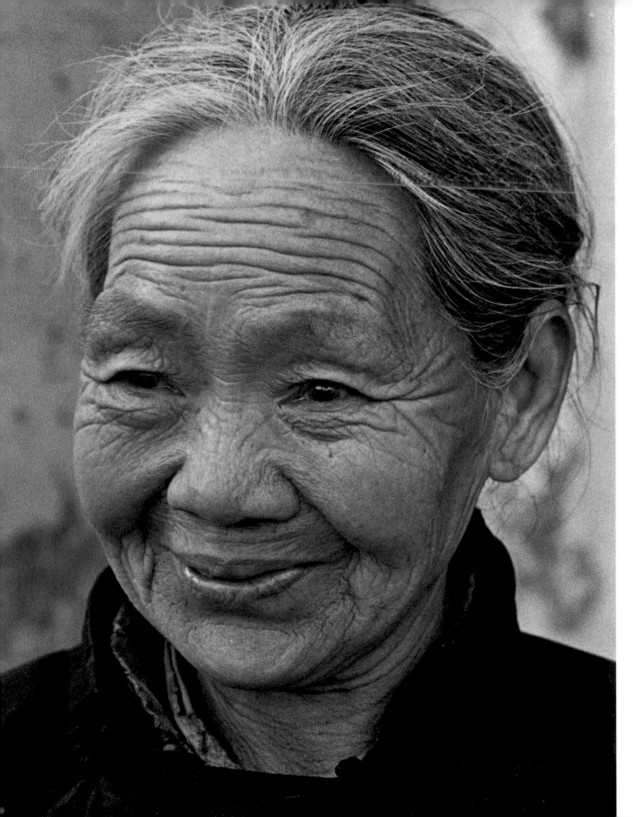

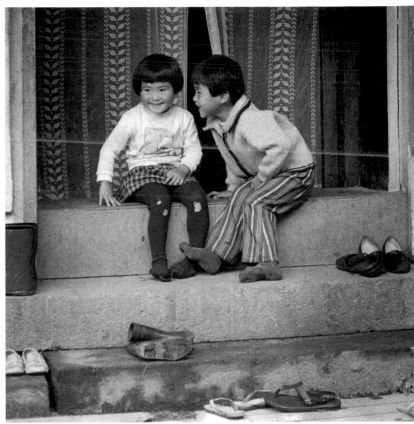

Japan

China

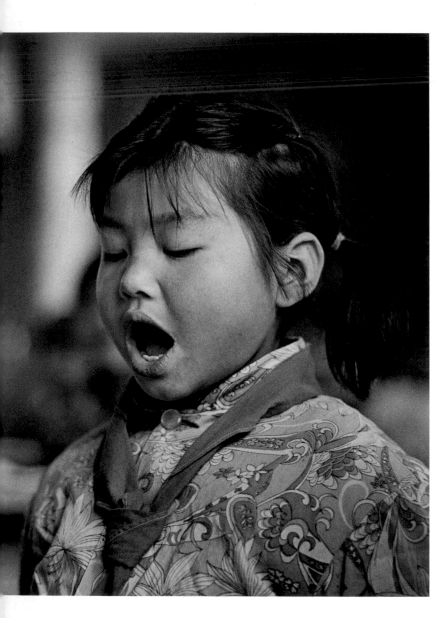

China

■ Early one morning in Hong Kong I stood at the end of an old pier, photographing life as it unfolded aboard the many junks and sampans. The air was filled with a blue haze. Tiny fires for cooking were built on every deck. Strange odors permeated the atmosphere—some pleasant, some not. Fast-paced conversations came from all directions.

My viewfinder suddenly picked up a small boy at some distance climbing over dozens of boats to reach the gangplank that separated him from the outside world. He climbed ashore tightly clinging to a book, some paper, and one big pencil. Within seconds he darted through a warehouse door.

I followed, and came to a big old warehouse that had been converted into a temporary school for refugee children. It was holding a number of sessions each day. I was told some 100,000 school-age children were still waiting for the opportunity to attend some sort of training.

With my camera in hand I roamed from room to room. Children filled the place from wall to wall—there wasn't a vacant seat anywhere. You could have heard a pin drop. The power of concentration was electric. It had been a long, long time since I had seen such beautiful faces—faces so eager, alert, excited, and humble. It was a pleasure to record them.

I left realizing that not one child wasted a precious moment from his lessons to notice me, a foreigner in their midst.

Hong Kong

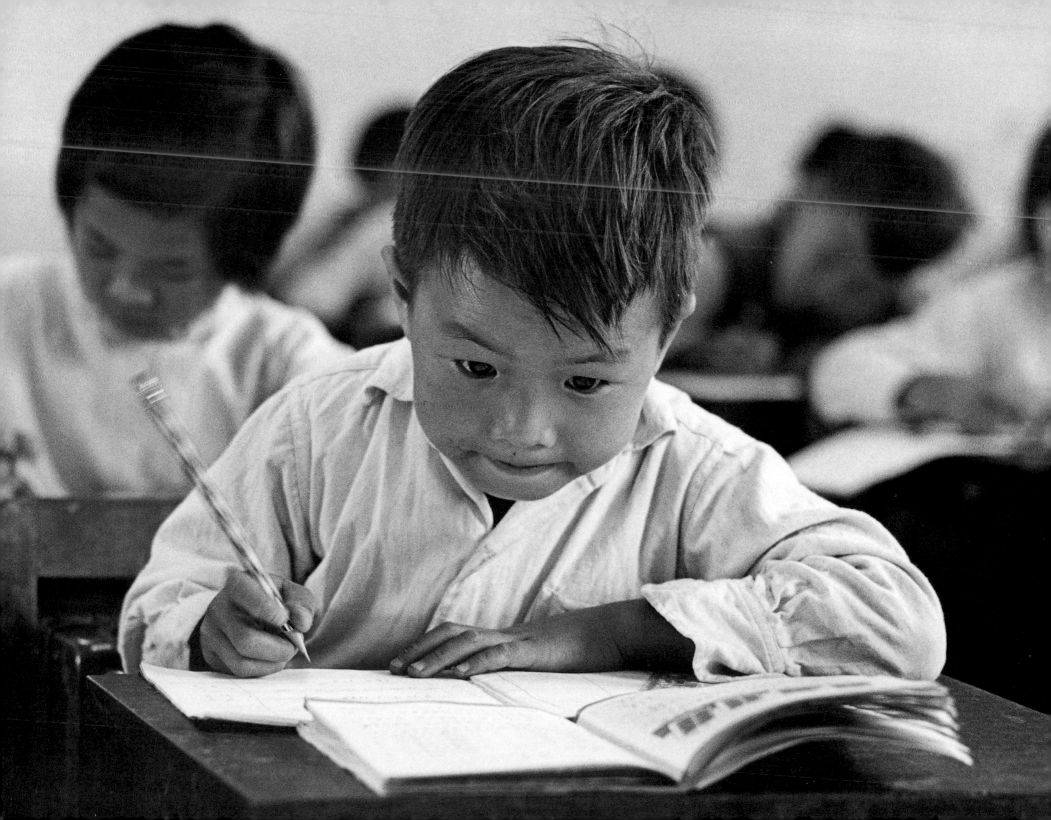

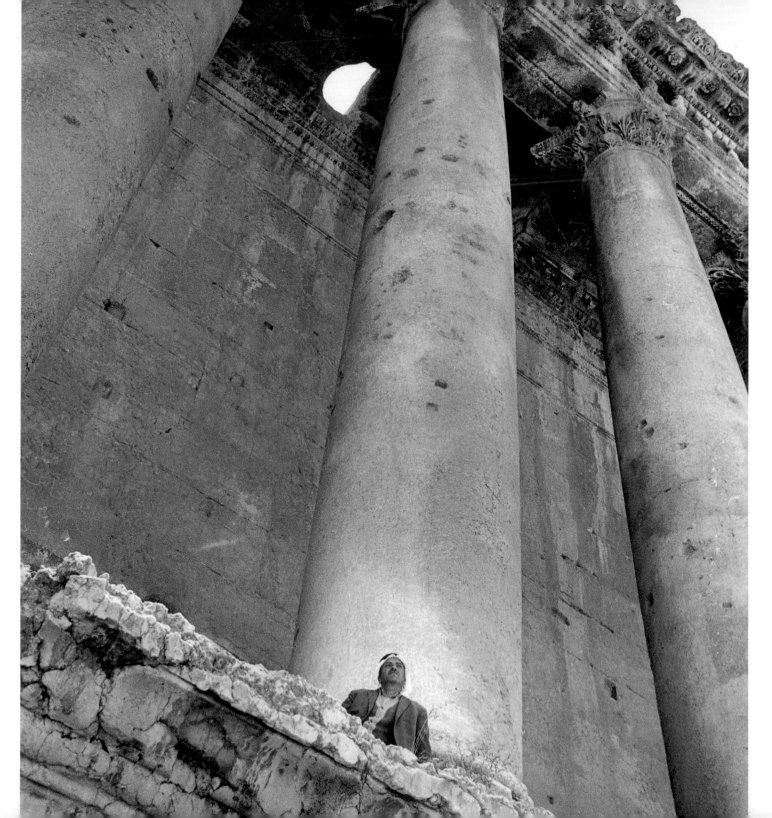

Lebanon

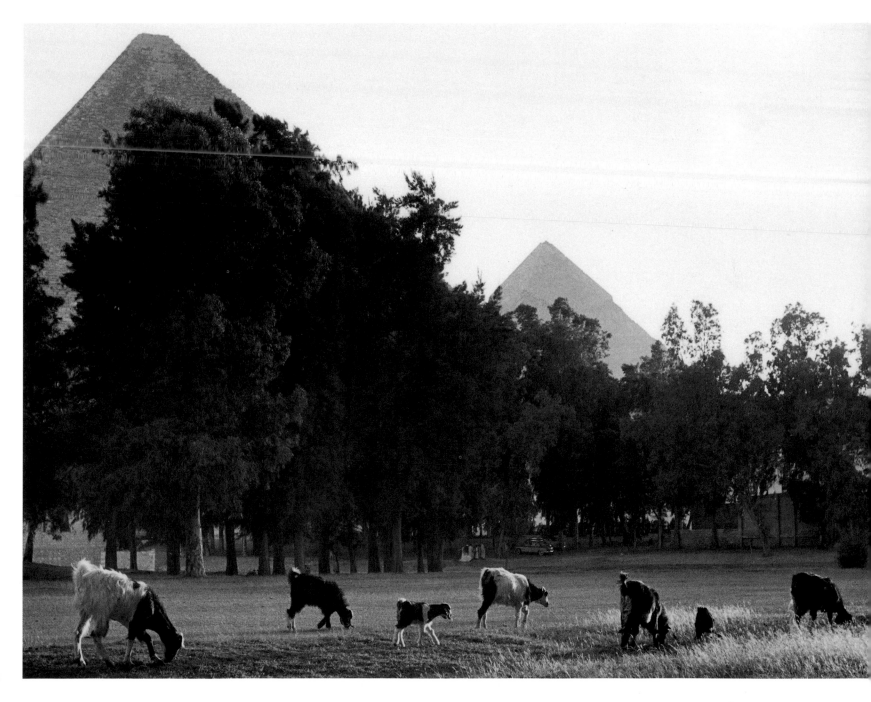

Cairo, Egypt

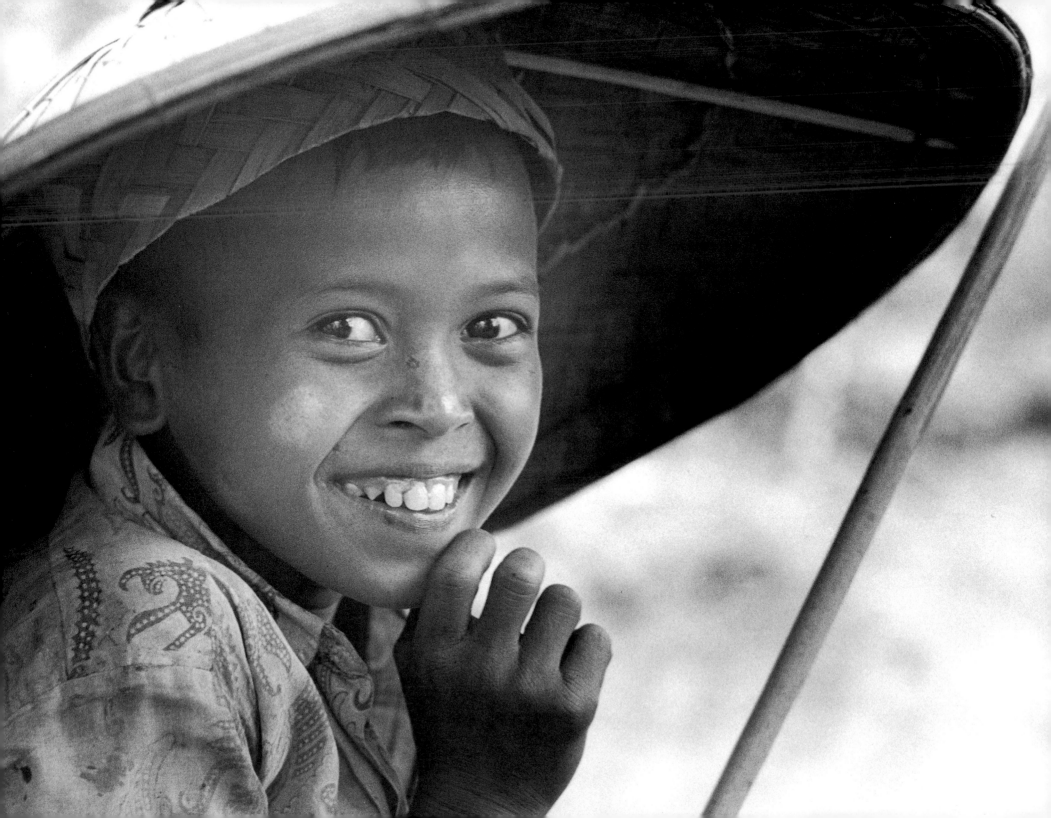

I have always liked to photograph children because they are honest. Children have no false beliefs. Their expressions are so honest and they are so outgoing.

Bali, Indonesia

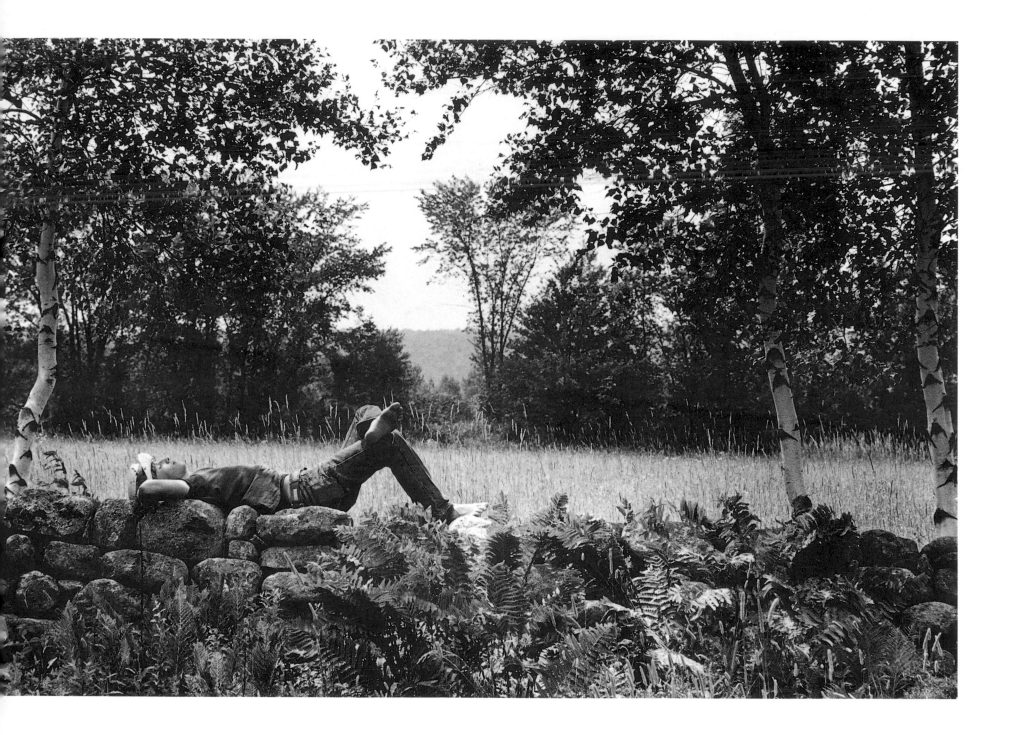

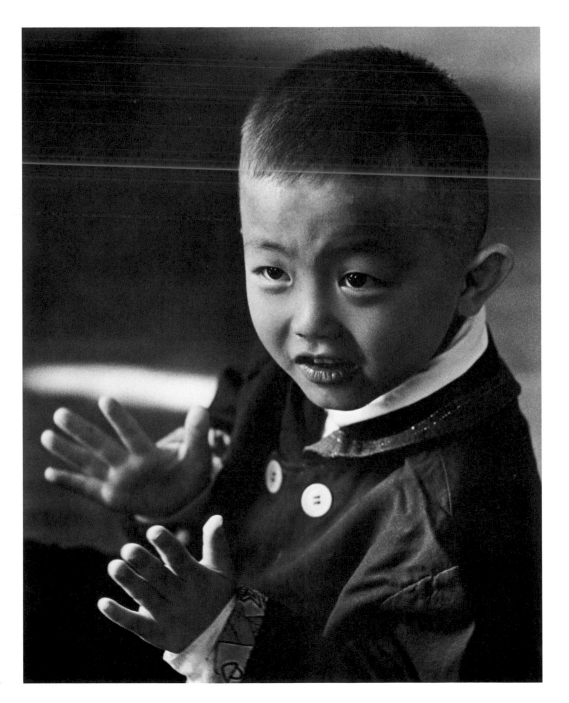

China

Norway

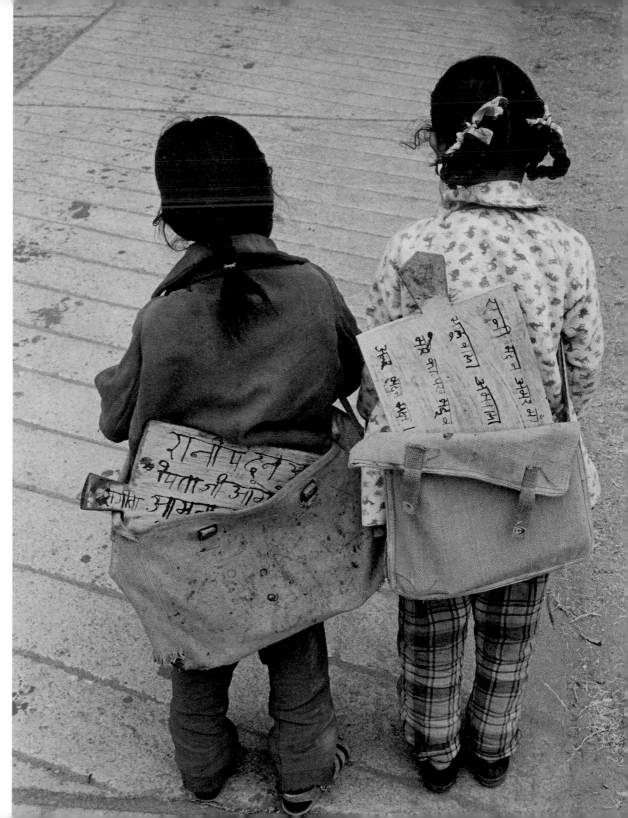

China

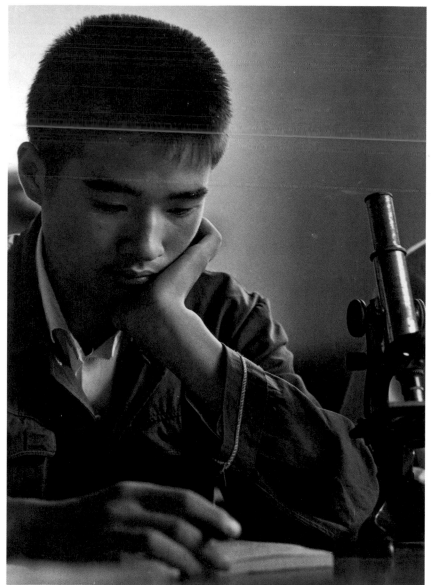

China

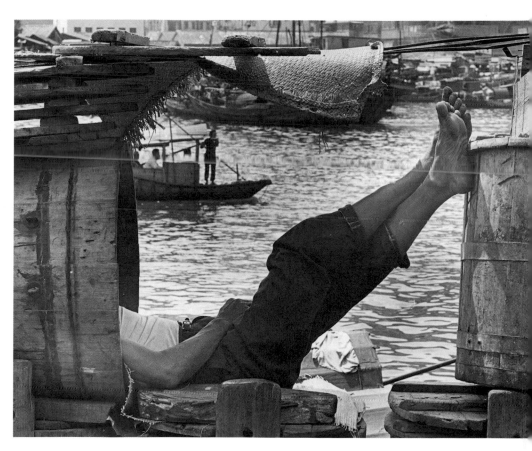

Hong Kong

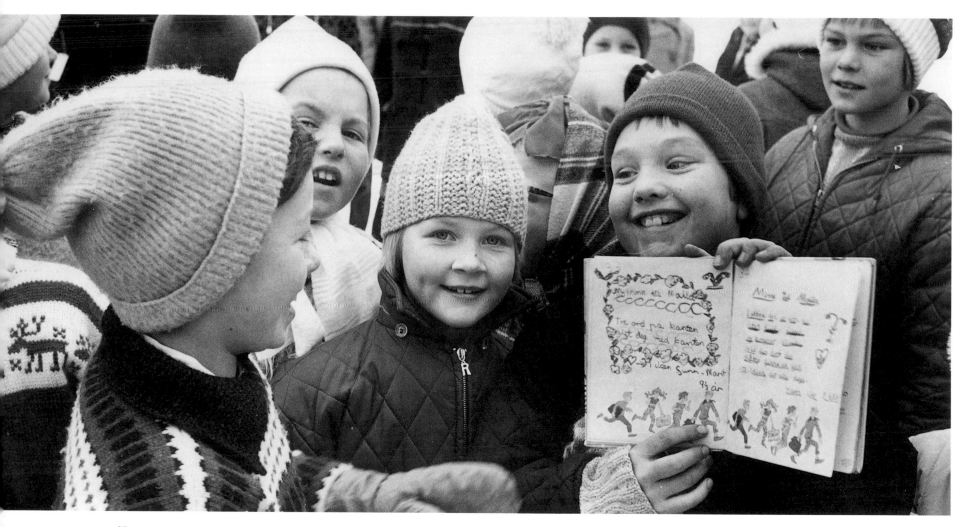

Norway

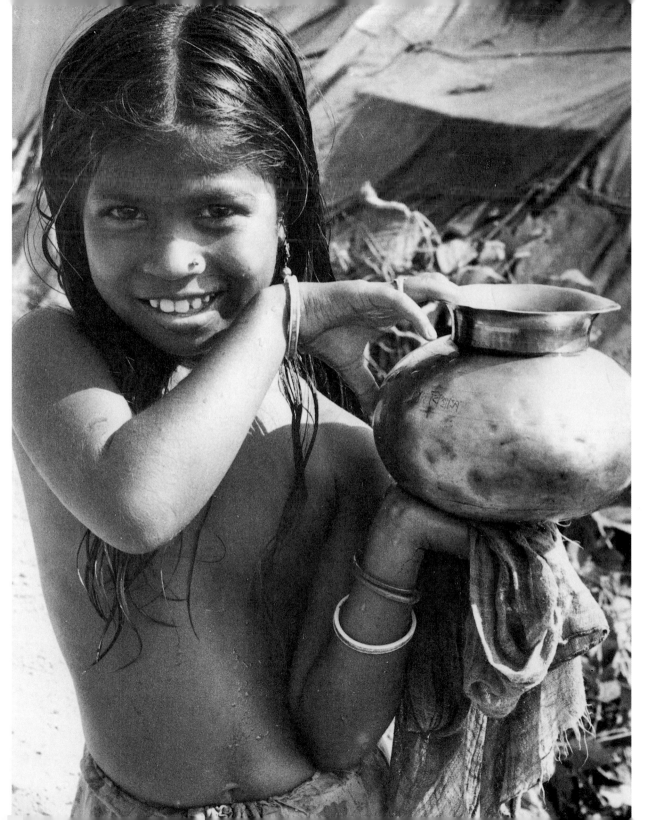

India

Children are much easier to communicate with because they don't resist the way adults do.

Bali, Indonesia

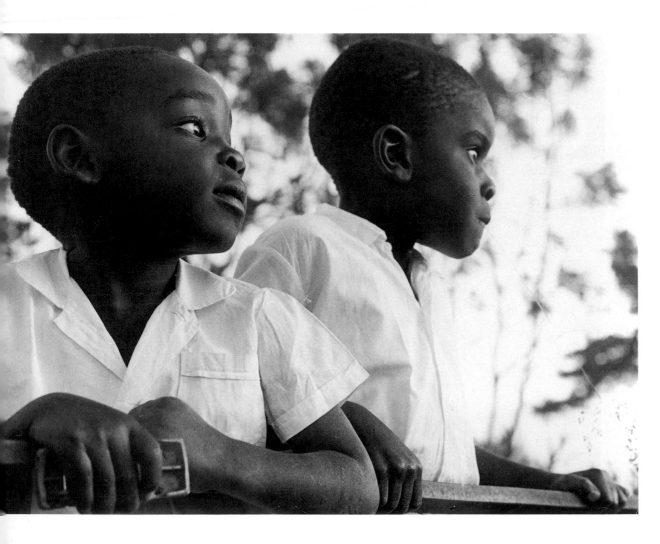

Nairobi, Kenya

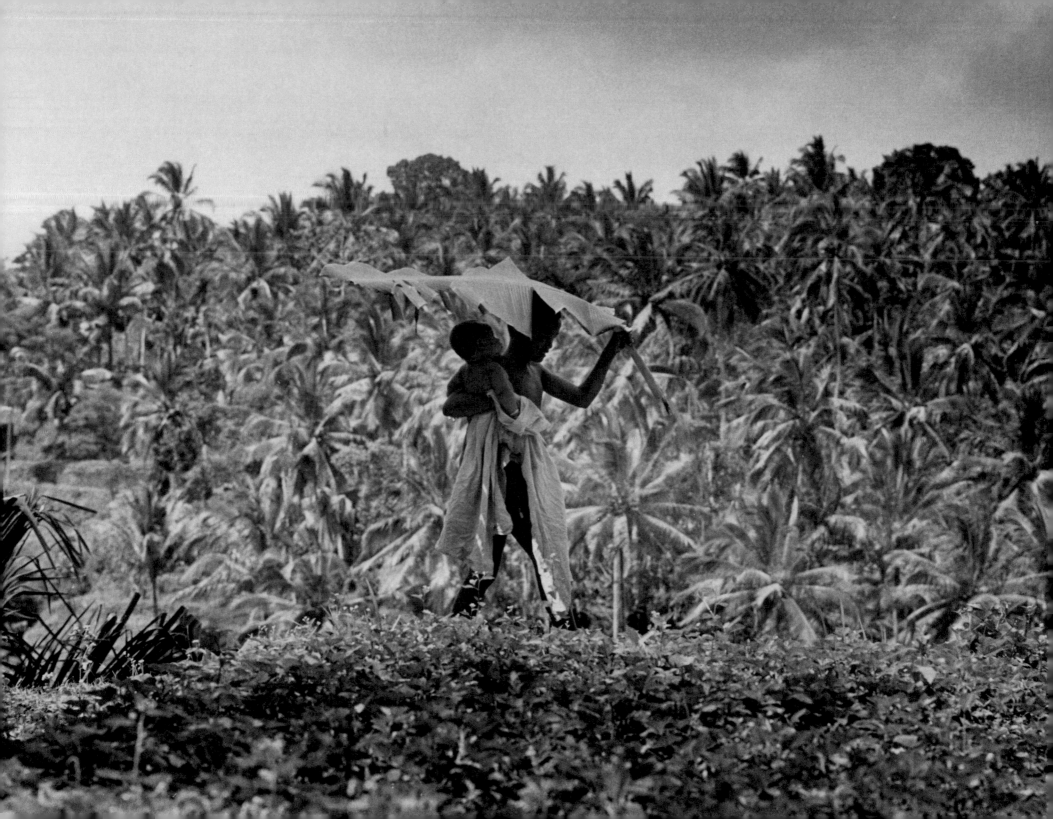

I love the innocence of children's thoughts. I love the purity of their faces and expressions— untouched, unharmed expressions.

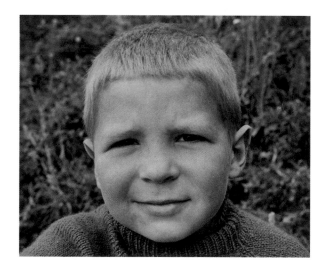

Norway

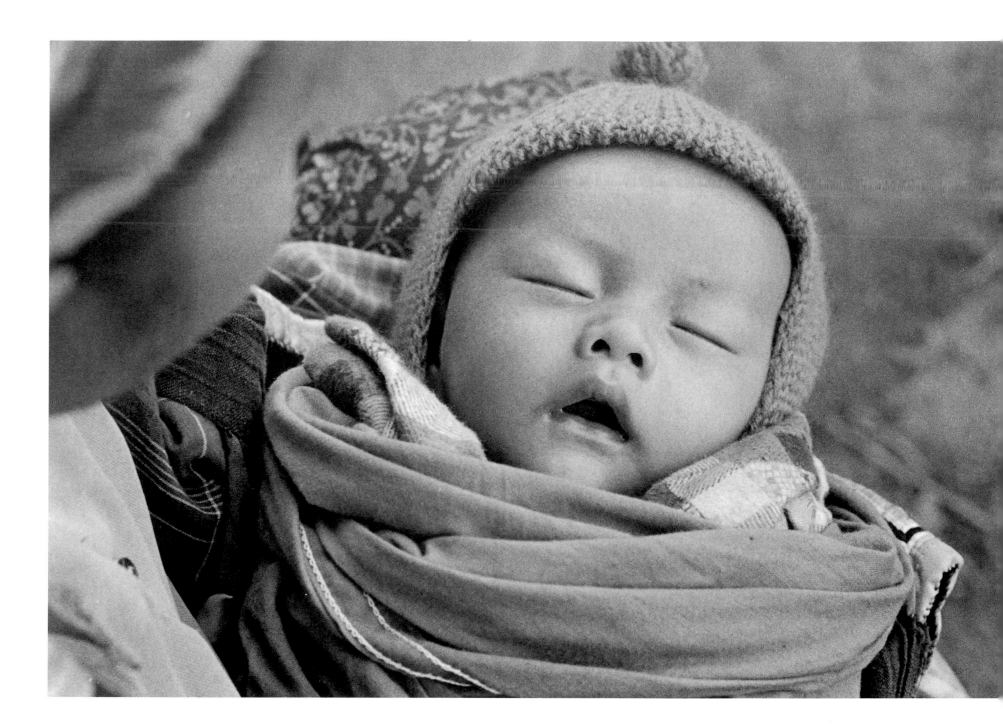

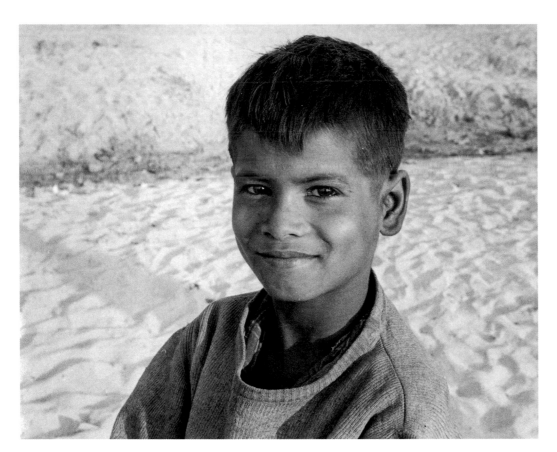

Israel

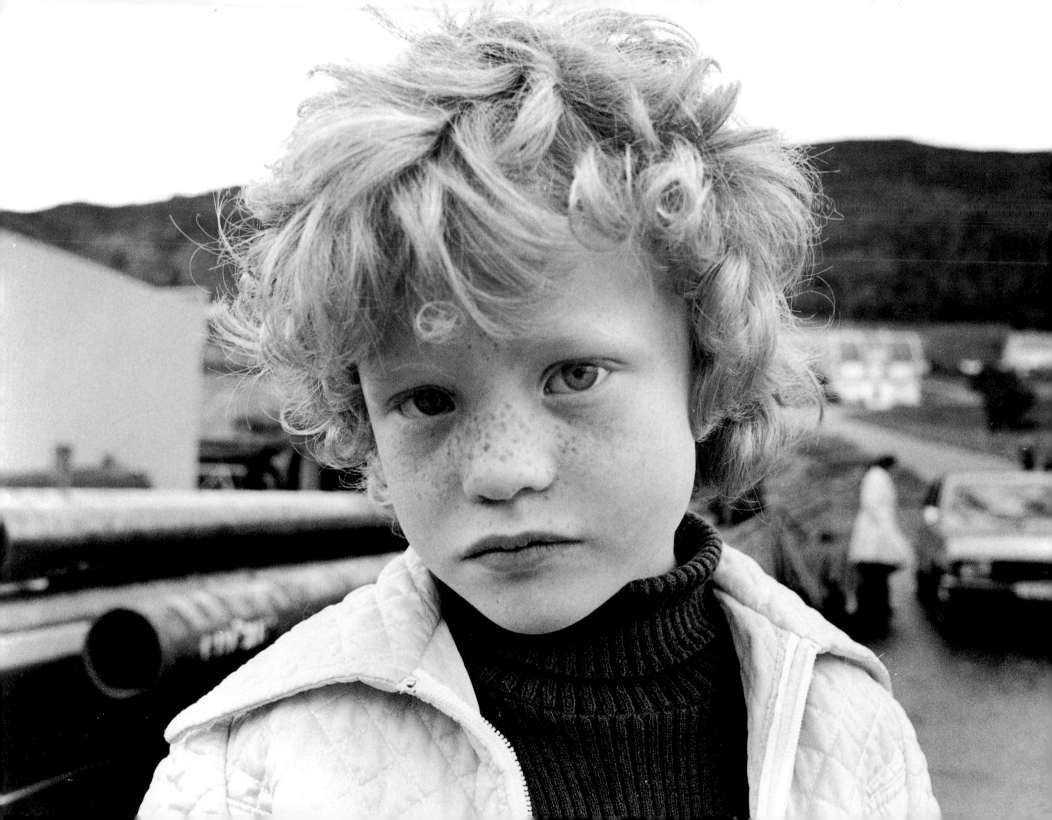

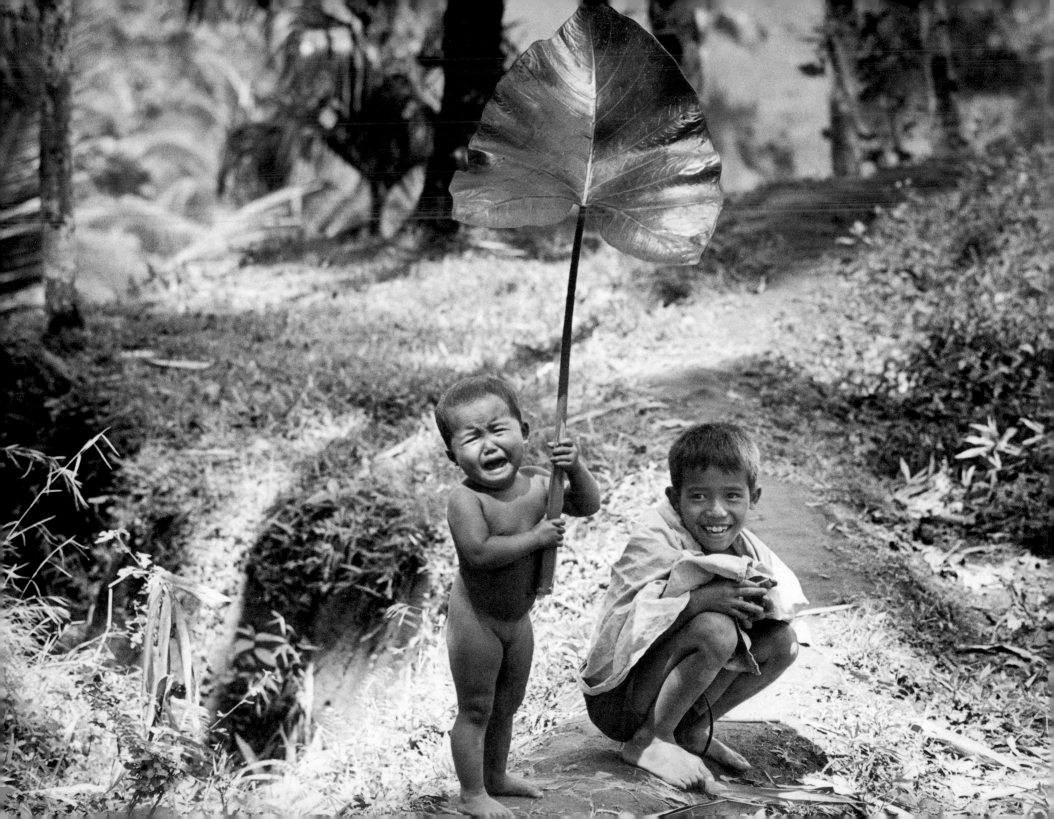

I have seen that children occupy very special places in the hearts of so many peoples. They have seemed to me always to be symbols of future hopes, even during the most troubled of times.

■ I found these two children in Indonesia, on the island of Bali. I had come upon them suddenly, and obviously had two very different reactions—both equally honest and childlike.

Bali, Indonesia

Kyoto, Japan

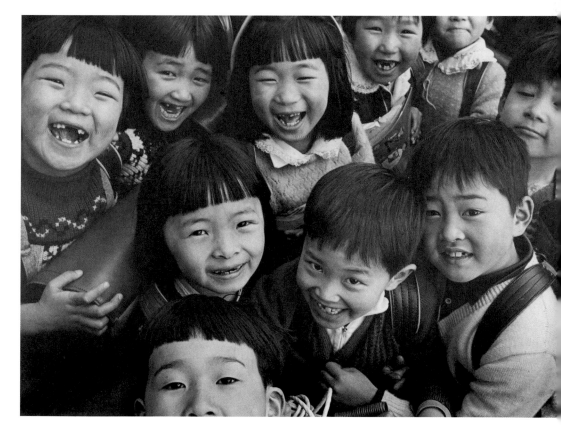

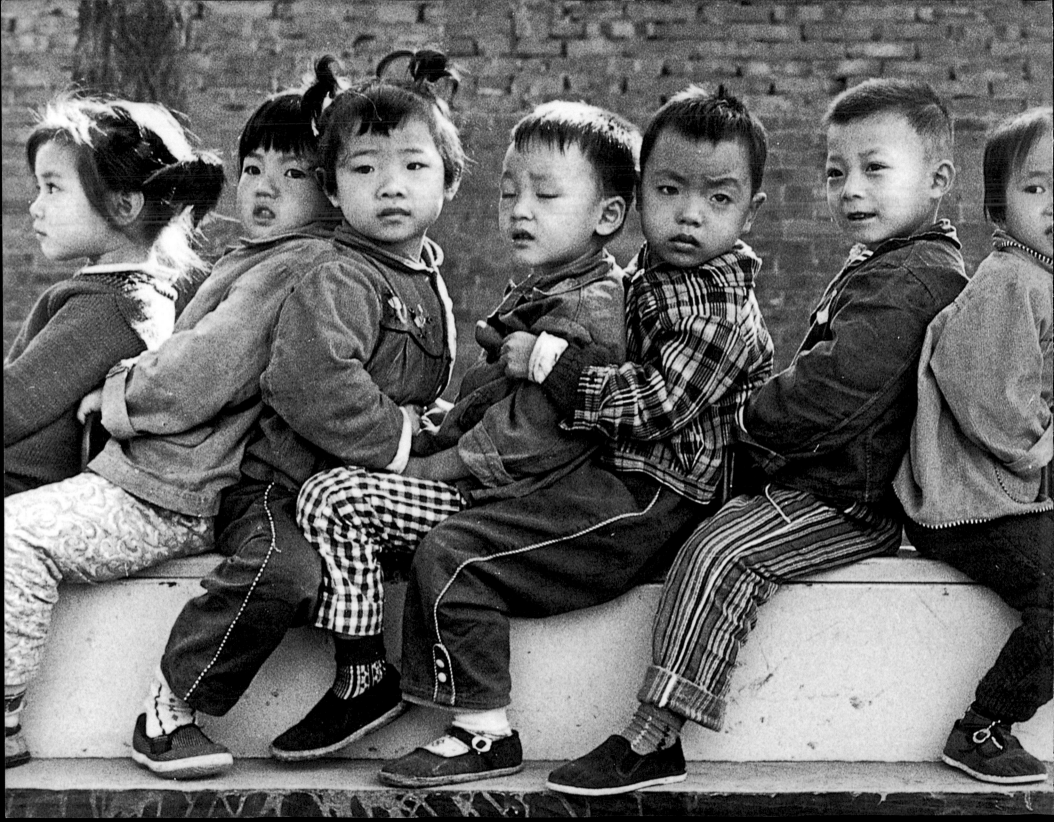

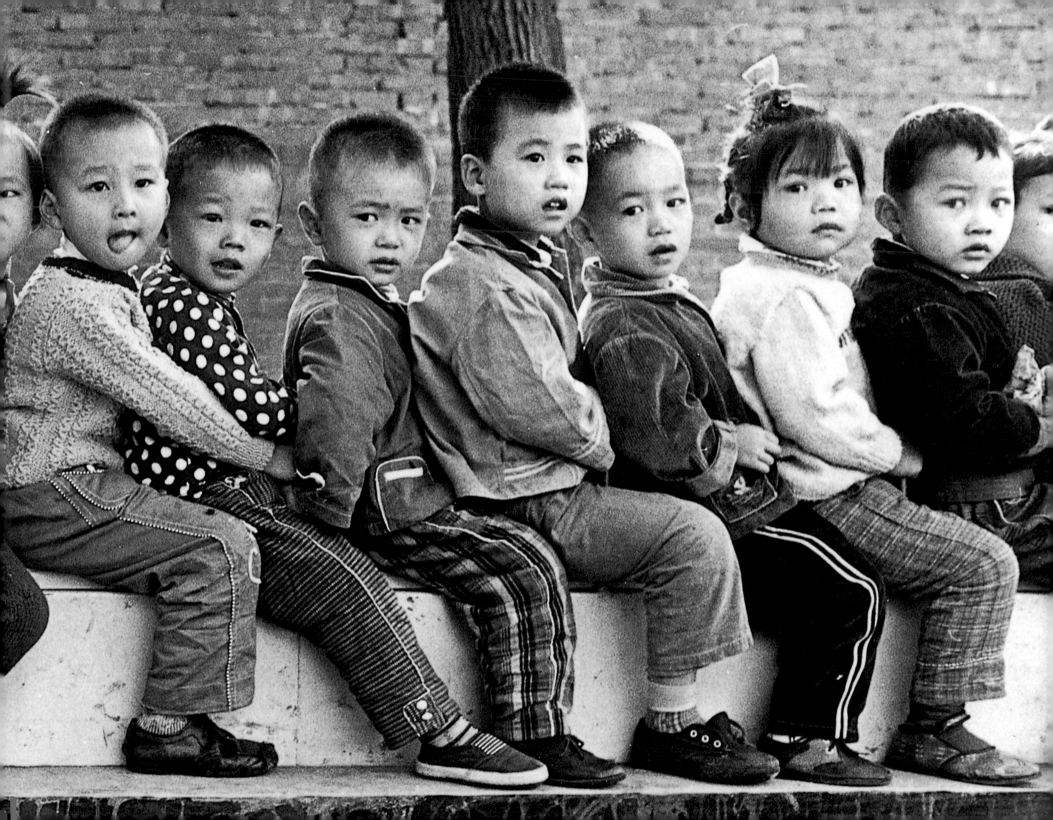

In 40 years of assignments, I never had to return to work and say, "there's no picture." Successful photographers are seldom completely satisfied with their results. They are always striving for something new and better. If working conditions were poor and I wasn't happy with the results, I would ask myself if anyone else could have done the job better under the same conditions. If the answer was an honest "no," I would then release my work to the editors with a clear conscience.

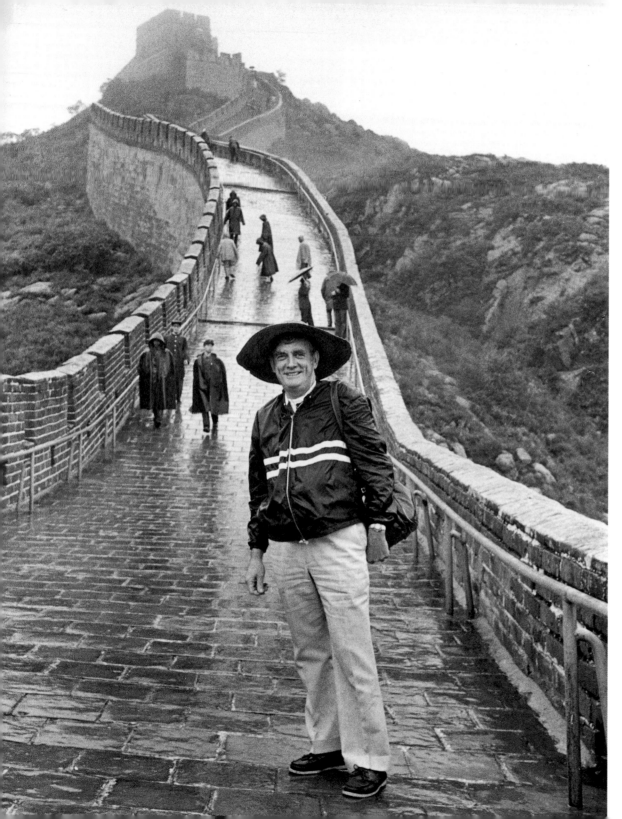
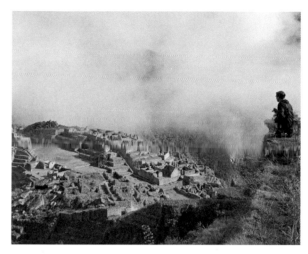
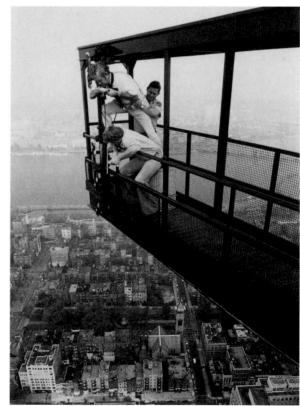